50%
The Visible Woman

Penelope
Slinger

50%
The Visible Woman

When the 'charming woman' shows
herself in all her splendour, she is a much
more exalted object than the 'idiotic paint-
ing over-doors, scenery, show-man's garish
signs, popular reproductions', that excit-
ed Rimbaud; adored with the most mod-
ern artifices, beautified according to the
newest techniques, she comes down from
the remoteness of the ages, from Thebes,
from Crete, from Chichen-Itza; and she is
also the totem set up deep in the African
jungle; she is a helicopter and she is a bird;
and there is this, the greatest wonder of
all: under her tinted hair the forest murmur
becomes a thought and words issue from
her breasts. Men stretch forth avid hands
towards the marvel, but when they grasp
it, it is gone; the wife, the mistress, speak
like everybody else through their mouths:
their words are worth just what they are
worth: their breasts also. Does such a fu-
gitive miracle—and one so rare—justify us
in perpetuating a situation that is bane-
ful for both sexes? One can appreciate the
beauty of flowers, the charm of women, and
appreciate them at their true value; if these
treasures cost blood or misery, they must
be sacrificed.

Simone de Beauvoir
'The Second Sex'

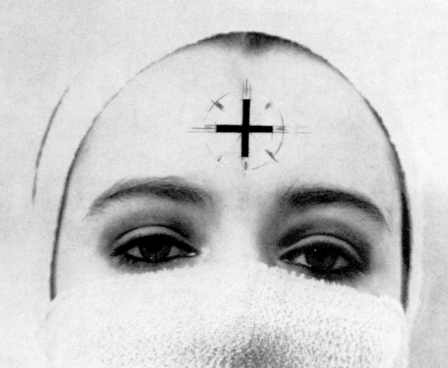

WANTED

THE OBJECT

THE OBJECT

SELF EXAMINATION

1. Question: Can irony achieve social change?

2. Question: Is the 'poetic image' a red herring?

3. Question: What divides the 'men' from the 'boys'?

4. Define aesthetics.

5. Unlock the book.

SELF EXAMINATION

1. Question: Can irony achieve social change?

2. Question: Is the 'poetic image' a red herring?

3. Question: What divides the 'men' from the 'boys'?

4. Define aesthetics.

5. Unlock the book.

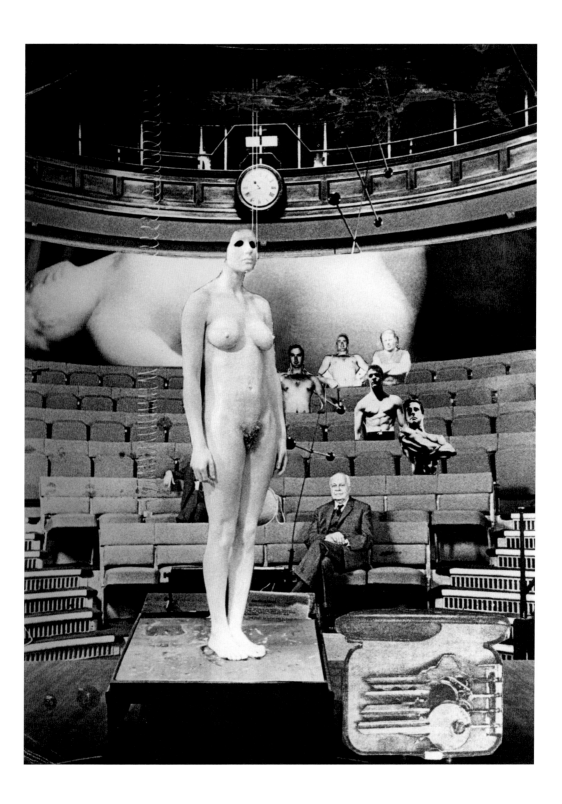

The 'new wave',
is but the old sea restated.

The veils of darkness
opened
and I took myself in hand.

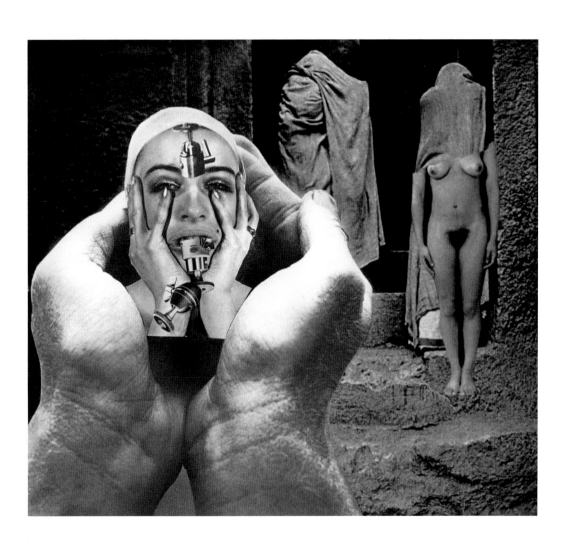

Monument to everlasting

c
r
u
c
i
f
i
x
i
o
n

(The rape of the adulteress)

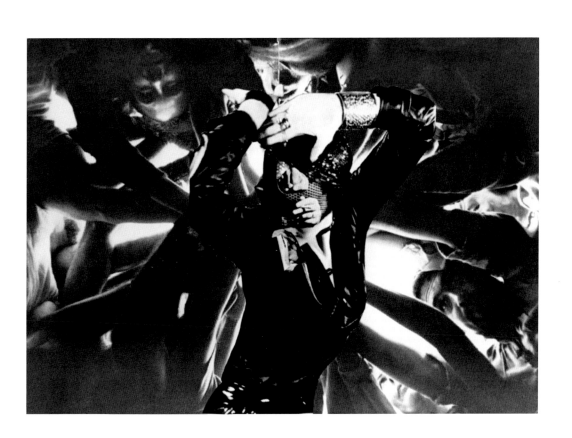

Pass the parcel

(Mass-production
of the archetype).

Pass the parcel

(Mass-production
of the archetype).

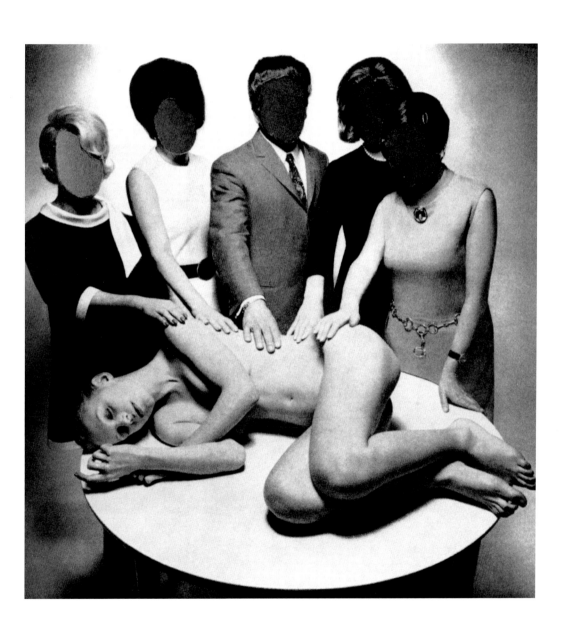

C
a
r
e
s
s
i
n
g or mutilating

I am the fleshy octopus

turned in

voluptuous

to its core

I am a woman

frightened

by the dark.

Caressing

or mutilating

I am the fleshy octopus

turned in

voluptuous

to its core

i am a woman

frightened

by the dark.

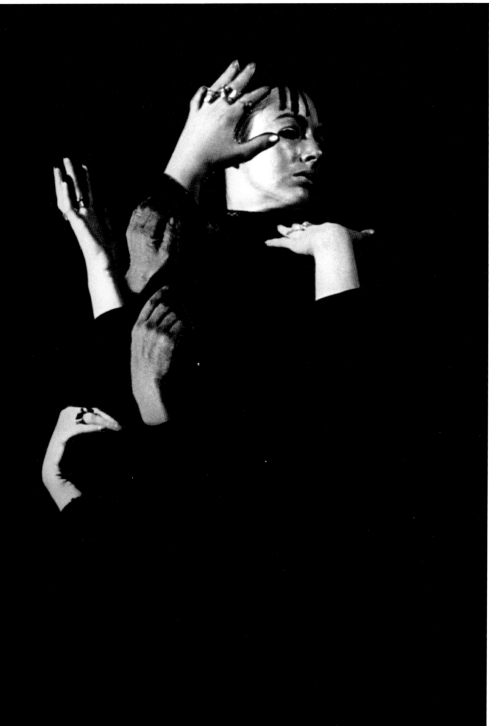

I am the half
man
has always been
looking for

The ever-open secret

your very soul image

See what charms
the never-ending kiss
holds for you

turn me around
you will see where I
move into you

Autonomous
you might say

In changing
I become
the same
eternal
open wound

Inhaling
and bringing forth
like some enormous
vacuum-cleaner

Like a soul
in limbo.

I am the half
man
has always been
looking for

The ever-open secret

your very soul image

See what charms
the never-ending kiss
holds for you

turn me around
you will see where I
move into you

Autonomous
you might say

In changing
I become
the same
eternal
open wound

Inhaling
and bringing forth
like some enormous
vacuum-cleaner

Like a soul
in limbo.

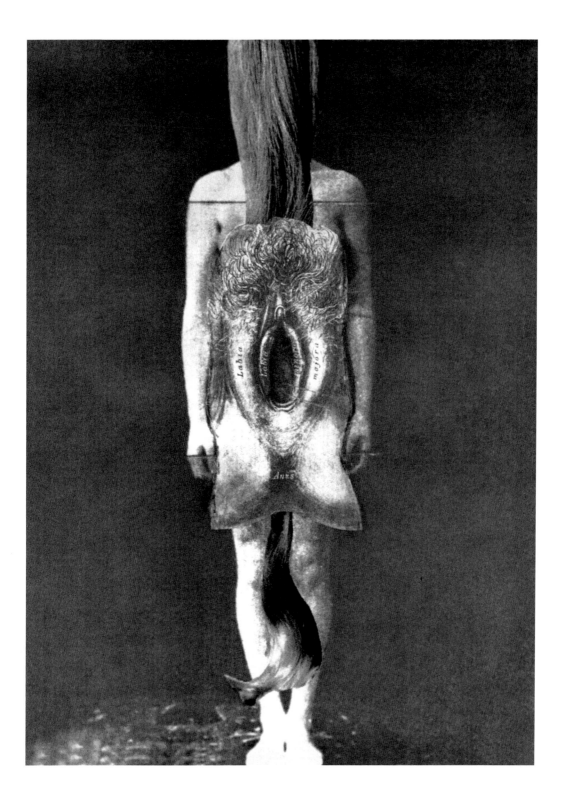

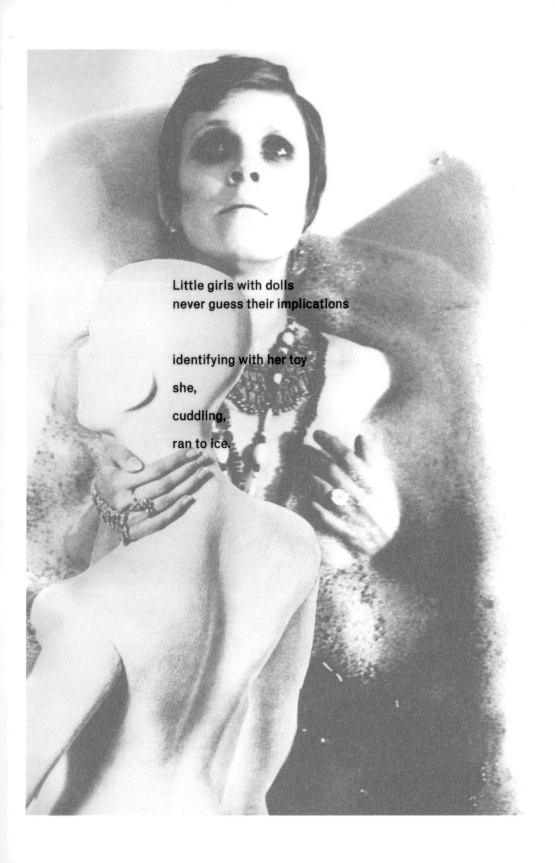

Little girls with dolls
never guess their implications

identifying with her toy

she,

cuddling,

ran to ice.

THE DISEMBODIMENT
EMBODIED

THE DISEMBODIMENT EMBODIED

Alice entered the looking-glass
and found Mummy and Daddy
inside the one-way mirror

'Child' is a Victorian concept

Guilt is the closing of doors.

(And still she couldn't understand
the smell of plastic
the rustling of clothes).

Alice entered the looking-glass
and found Mummy and Daddy
inside the one-way mirror

'Child' is a Victorian concept

Guilt is the closing of doors.

(And still she couldn't understand
the smell of plastic
the rustling of clothes).

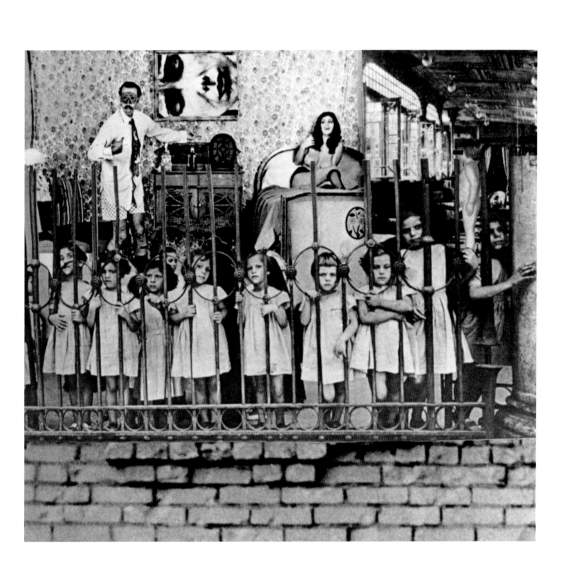

I was the third party

 witness

compelled to set out
on a life of crime.

I was the third party

witness

compelled to set out
on a life of crime.

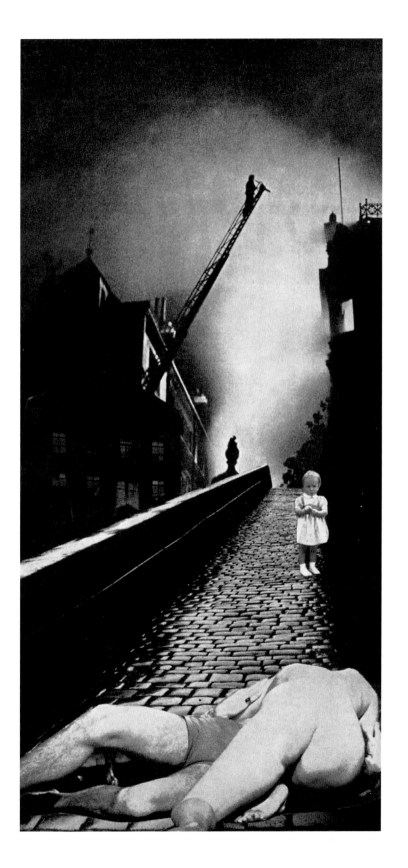

TWENTIETH CENTURY
RECONSTRUCTION
OF THE VENUS D'IMAGO

Definitions: —

Monster of disjuncture.

A fig-leaf fastened in the mind

Product of the

anti-naturalistic tendency
in art.

Classical figure
of
alienation.

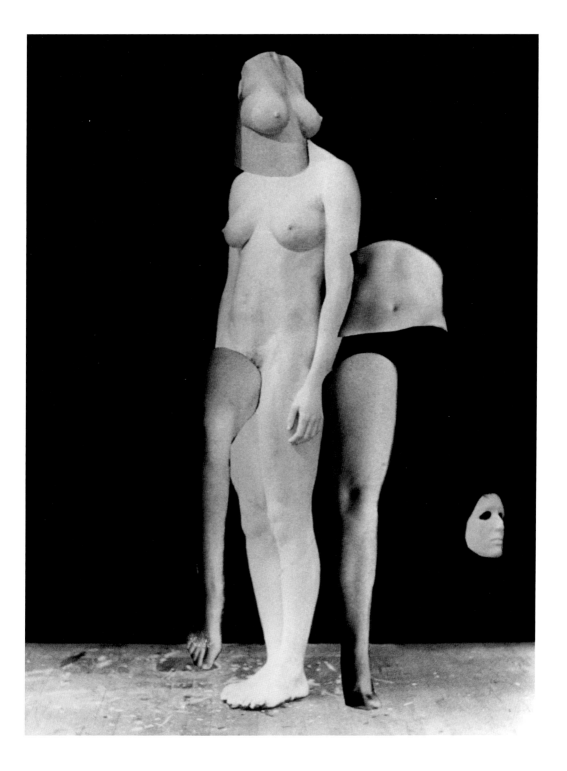

The dialectics of experience

present a new hierarchy

evoked in the shadows

a presence using emblems

like a clown

A collage exploits itself

A corner seeking identity

in its absence of form

The dialectics of experience

present a new hierarchy

evoked in the shadows

a presence using emblems

like a clown

A collage exploits itself

A corner seeking identity

in its absence of form

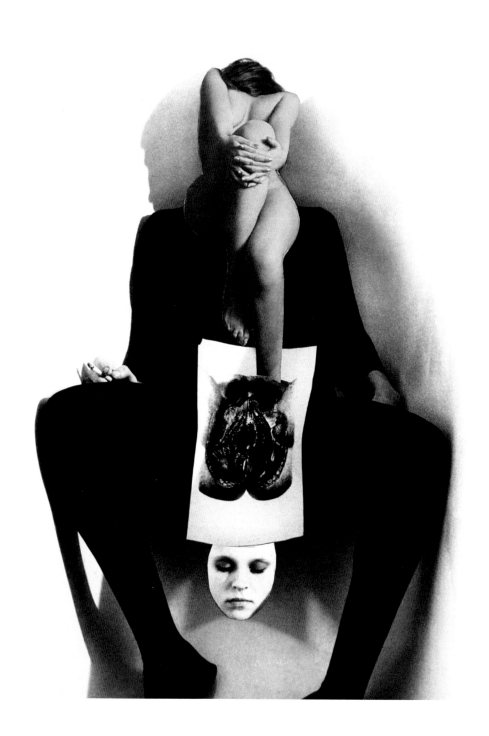

FOR THE MANTELPIECE

Sister to the woman

Magritte 'Raped'.

She had an open face

you could read her

like a book.

'The Gates of Heaven and Hell',

Eve after the Fall.

Her confinement.

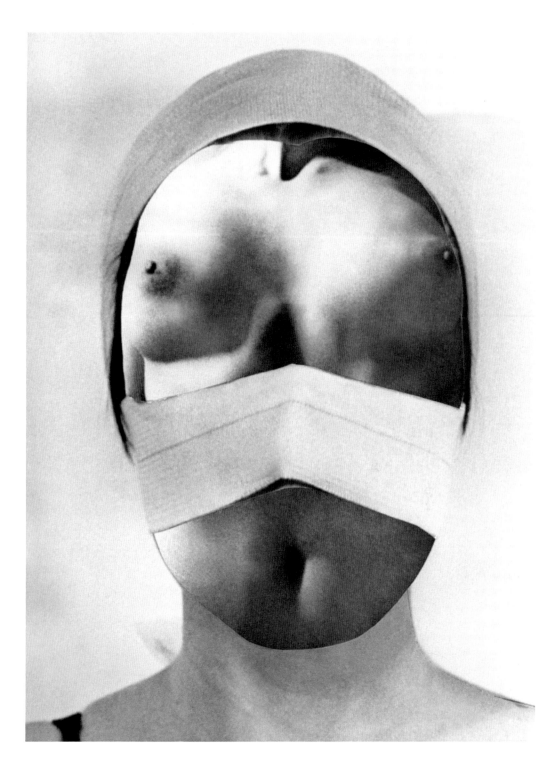

When the head leaves the body

Is its isolation self-conscious?

Is my face the mask's identity?

How many children

are born from the bodiless head?

Will your potency be threatened

by the destruction of my grand facades?

('Put on your mask, and I'll tell you who you are').

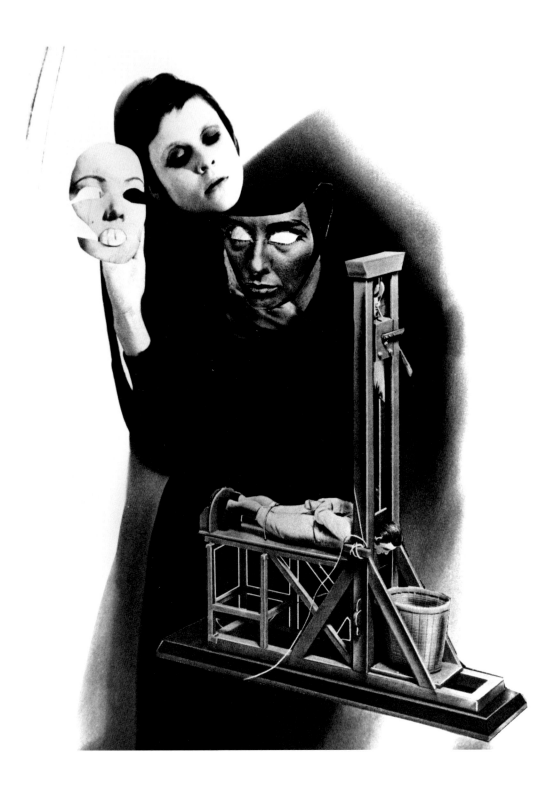

THE ARMOUR

THE ARMOUR

'Don't look at me
in that tone of voice' —

Meanwhile,

on the seashore,

the ritual sacrifice
took place.

'Don't look at me
in that tone of voice.' —

Meanwhile,

on the seashore,

the ritual sacrifice
took place.

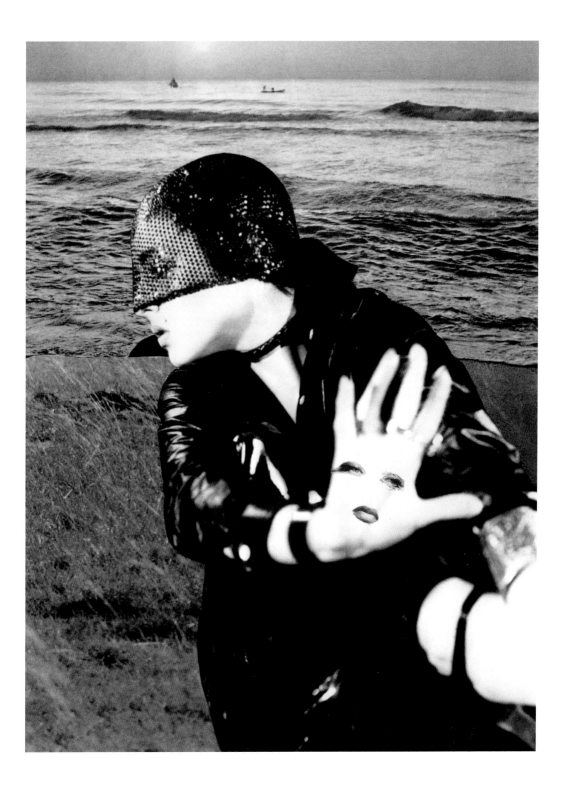

As the portcullis

was lowered

the army of Amazons

sieged the tower.

(But the drawbridge

over the water

was temporarily

OUT OF ORDER

Medusa wanted to free herself

and the moat was very inviting).

As the portcullis

was lowered

the army of Amazons

sieged the tower.

(But the drawbridge

over the water

was temporarily

OUT OF ORDER

Medusa wanted to free herself

and the moat was very inviting.)

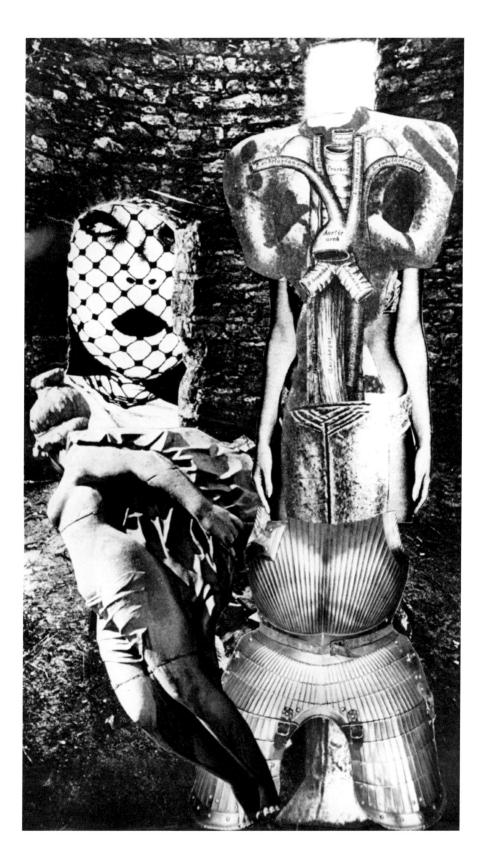

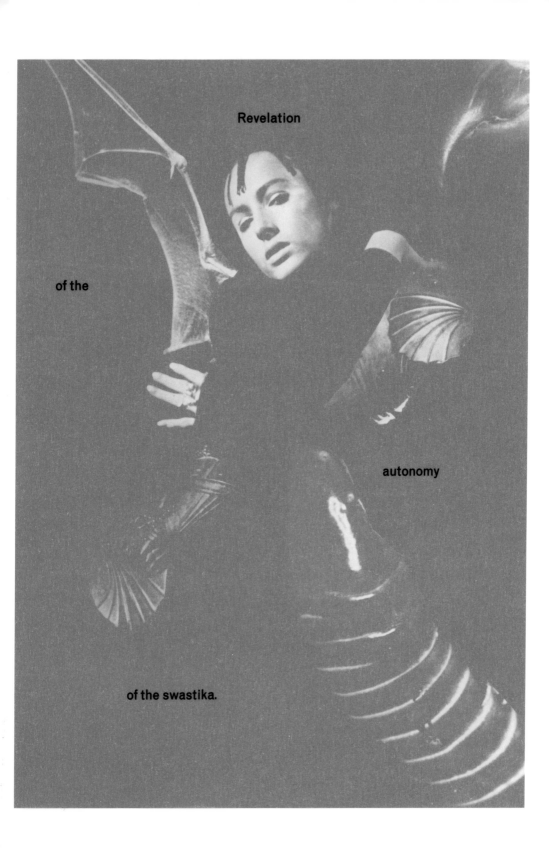

Then Circe rose

triumphant

from the rock

fashioning steel about her

as her weapon

and her lure

using paradox
as her subtle

sorcerer.

Then Circe rose

triumphant

from the rock

fashioning steel about her

as her weapon

and her lure

using paradox
as her subtle

sorcerer.

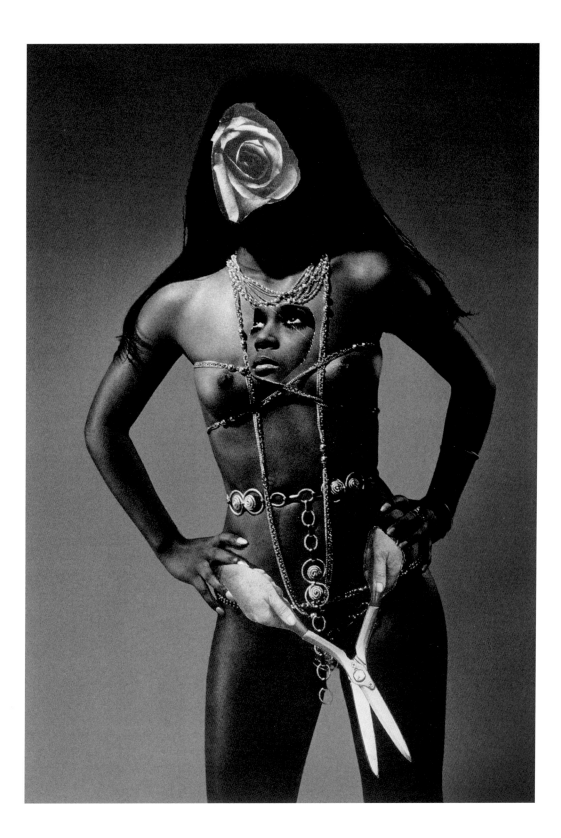

'You are always
poking your nose' —

My seductive pose
holds the armour up.

— 'Just whose side
are you on?' —

(My chains are deceptive
I relate to Cleopatra).

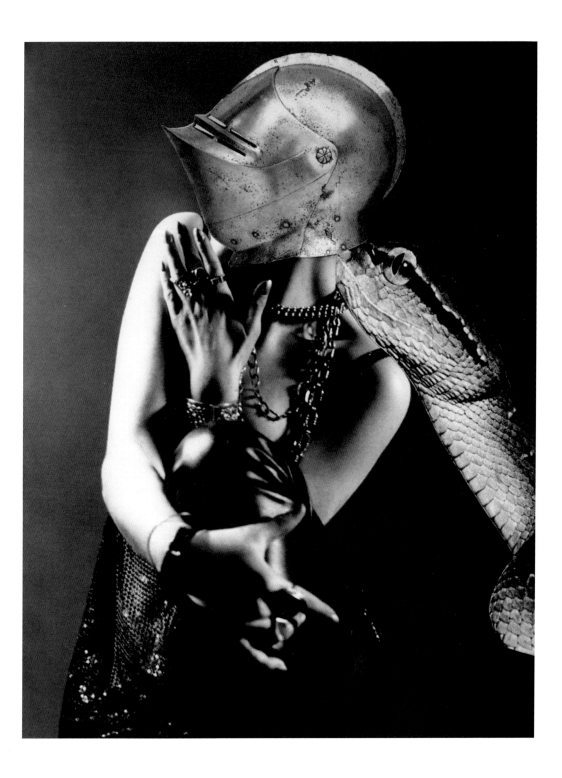

The armory show

exhibits

your enigmatic smile

This week's offer

is the new woman

(as advertised)

Her articulated breastplate

is self-explanatory.

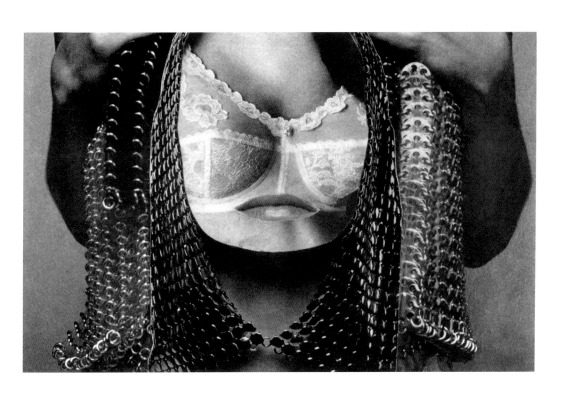

Inside Outside

Above Below

 Womb

 Bath

 Sacrophagus

Fragility Durability

Preservation Decay

Deep Shallow

Skin and Bone

 Life after Death

 o
 p
 e
 n

 and shut.

Inside Outside

Above Below

Womb

Bath

Sacrophagus

Fragility Durability

Preservation Decay

Deep Shallow

Skin and Bone

Life after Death

o
p
e
n
and shut.

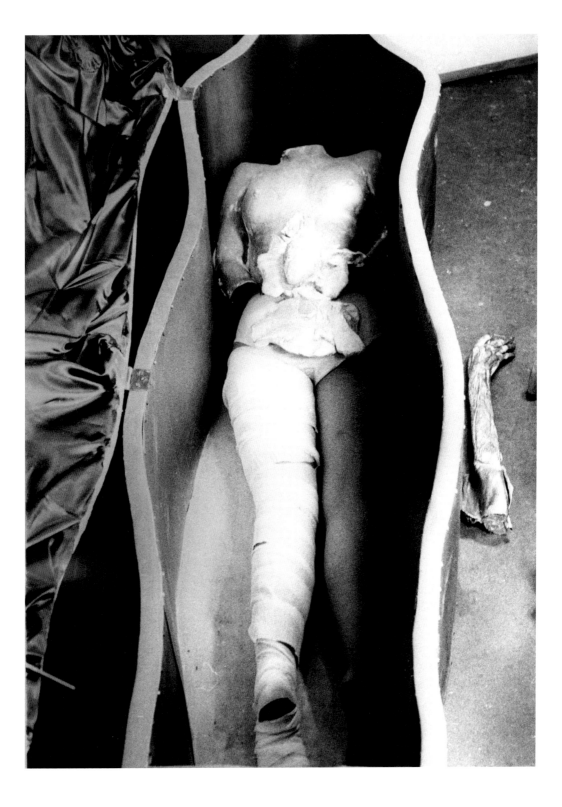

THE MASKS

THE MASKS

Peeling off my image
erupts the demi-monde
of the reflection without face

and the courtesans gather
like frightened children
behind the gaping wound.

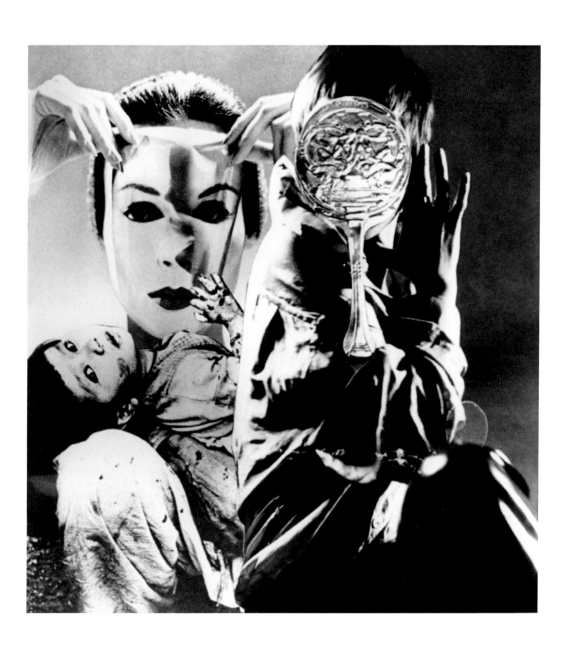

In the looking-glass
the same woman as Alice
before the break-through.

'Mirror, mirror on the wall . . . '

The breasts which blossomed
beneath her touch
now fasten round her
as a grand facade.

— — The same woman — —

with her sisters
with her shadows
forming bodies
as a box.

In the looking-glass
the same woman as Alice
before the break-through.

'Mirror, mirror on the wall . . .'

The breasts which blossomed
beneath her touch
now fasten round her
as a grand facade.

— — The same woman — —

with her sisters
with her shadows
forming bodies
as a box.

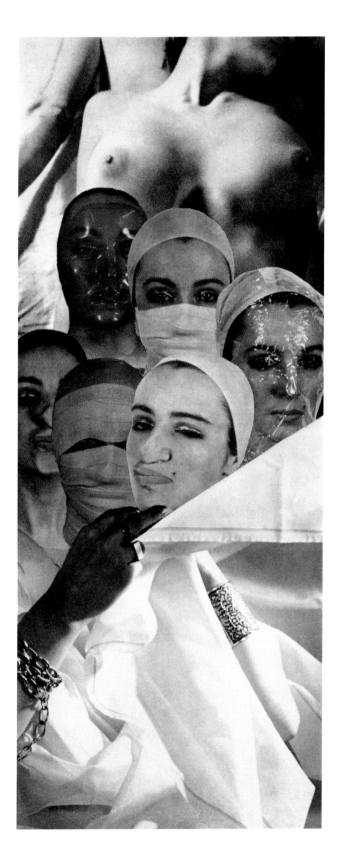

The play within the play.

The play within the play.

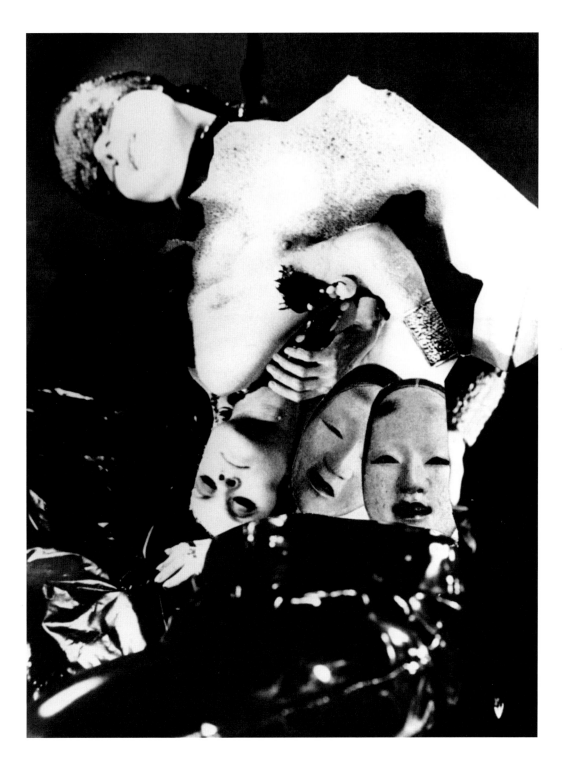

Our seduction was

beautified

(I never saw your face).

I see myself in you

I mutilate our love

Caressing my narcissus
undoing stealthily our blouse.

Our seduction was

beautified

(I never saw your face).

I see myself in you

I mutilate our love

Caressing my narcissus
undoing stealthily our blouse.

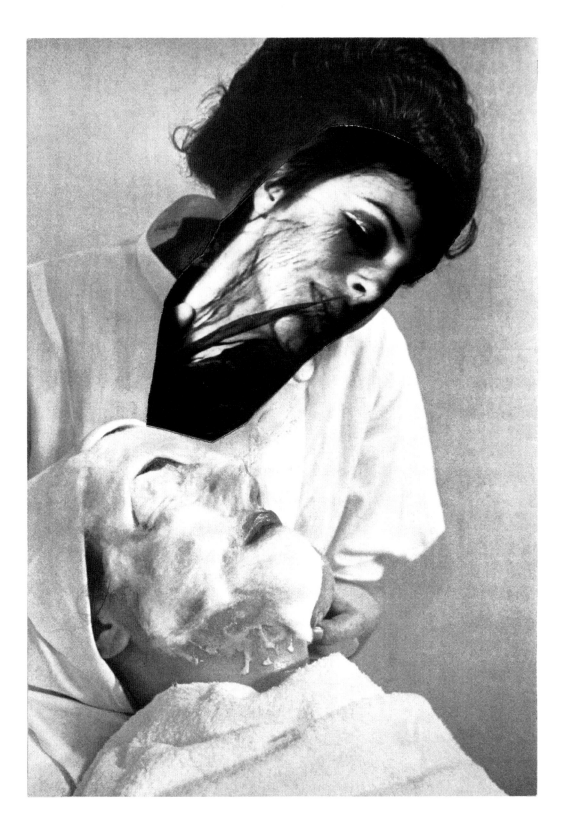

I couldn't

make-up

my mind.

I couldn't
make-up

my mind.

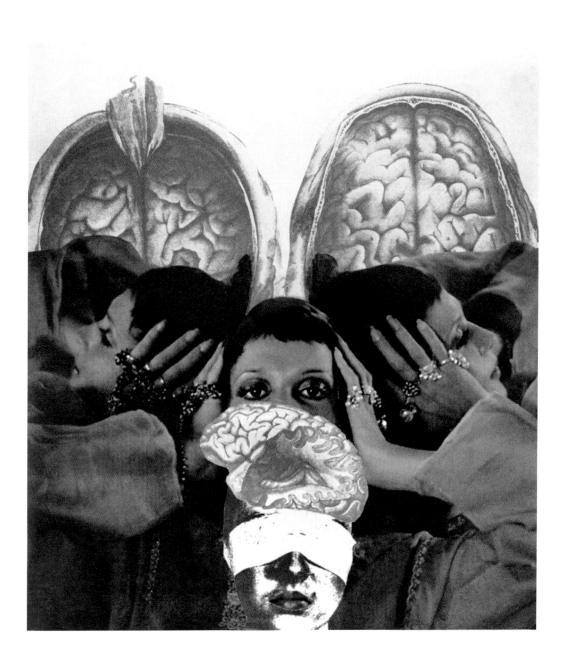

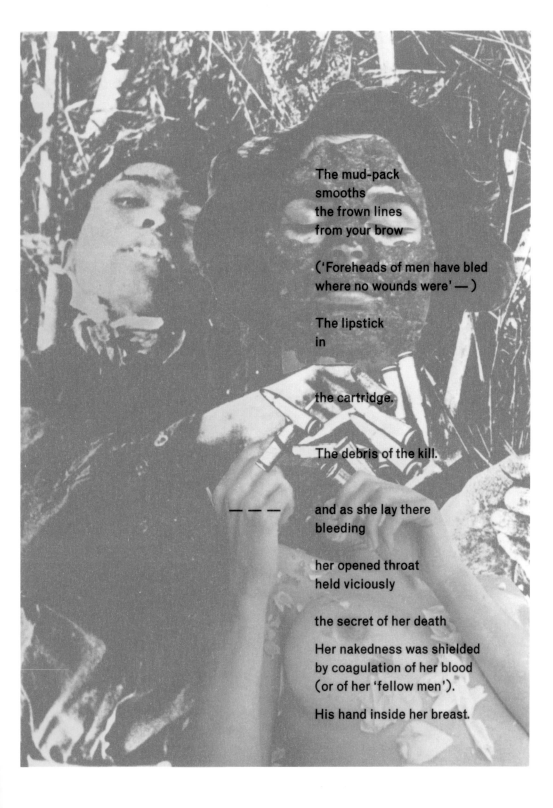

The mud-pack
smooths
the frown lines
from your brow

('Foreheads of men have bled
where no wounds were' —)

The lipstick
in

the cartridge.

The debris of the kill.

— — — and as she lay there
bleeding

her opened throat
held viciously

the secret of her death

Her nakedness was shielded
by coagulation of her blood
(or of her 'fellow men').

His hand inside her breast.

'And if the Babe is born a boy
He's given to a Woman Old,
Who nails him down upon a rock,
Catches his blood in cups of gold.

She binds iron thongs around his head
She pierces both his hands and feet,
She cuts his heart out of his side,
To make it feel both cold and heat,

Her fingers number every nerve,
Just as a miser counts his gold:
She lives upon his shrieks and cries,
And she grows young as he grows old.

Till he becomes a bleeding Youth,
And she becomes a Virgin bright;
Then he rends up his manacles,
And binds her down for his delight.'

'The Mental Traveller'
William Blake

'And if the Babe is born a boy
He's given to a Woman Old,
Who nails him down upon a rock,
Catches his blood in cups of gold.

She binds iron thongs around his head
She pierces both his hands and feet,
She cuts his heart out of his side,
To make it feel both cold and heat.

Her fingers number every nerve,
Just as a miser counts his gold:
She lives upon his shrieks and cries,
And she grows young as he grows old.

Till he becomes a bleeding Youth,
And she becomes a Virgin bright;
Then he rends up his manacles,
And binds her down for his delight.'

'The Mental Traveller,'
William Blake

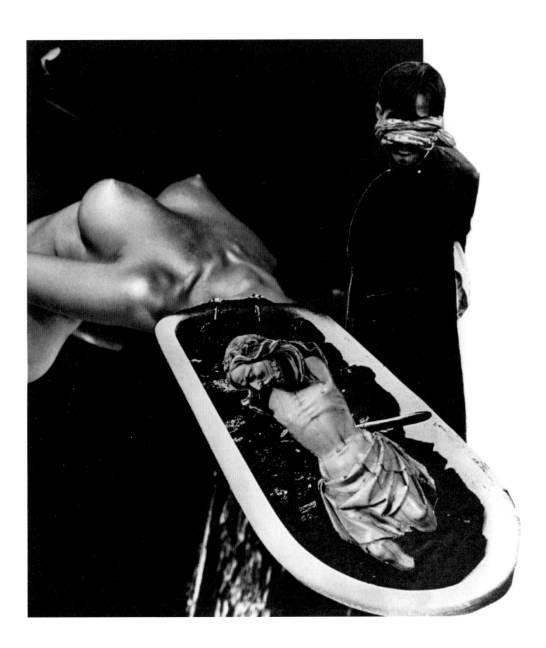

THE EARTH GODDESS/
EVE AND THE SERPENT

THE EARTH GODDESS /
EVE AND THE SERPENT

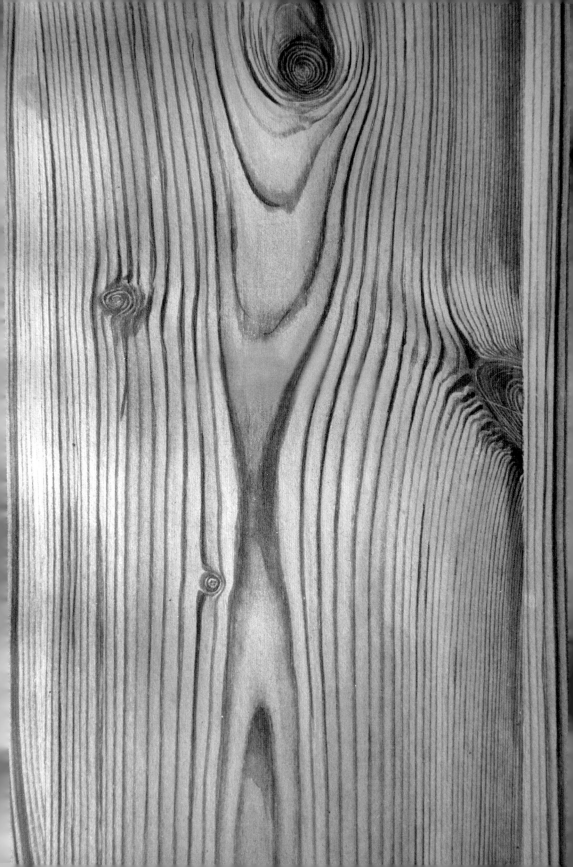

The fetish.

The fetish.

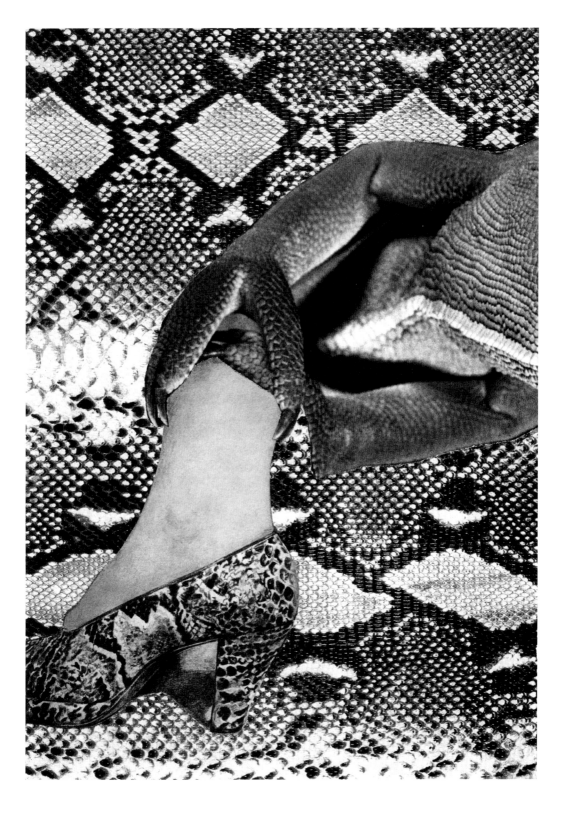

'The human is the longest living mammal'.
Survival of the . . .

. . . fitted with the cap
she no longer conceived.

The dirt clung to her thighs

like sticky jewels.

She adorned her head with faeces
and became a child again.

She murdered the Christ child.

'The human is the longest living mammal.'
Survival of the . . .

. . . fitted with the cap
she no longer conceived.

The dirt clung to her thighs

like sticky jewels.

She adorned her head with faeces
and became a child again.

She murdered the Christ child.

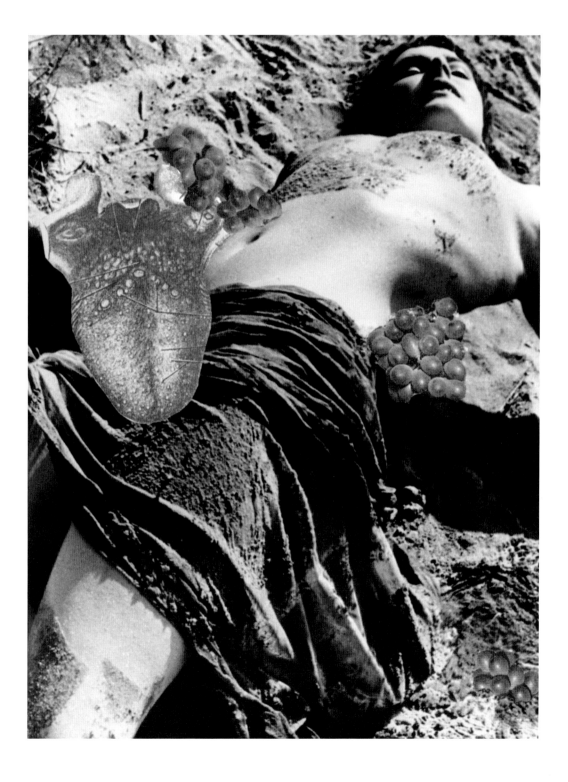

The grand impresario presents

the Wonders of the World

The dance of the seven veils

proved an attractive slideshow.

The Unveiling

shocked several menopausal women

in lizard-skin coats.

Arising from her own ashes

she claimed the status of the phoenix

and locked the door again.

The pillars of wisdom
caryatids

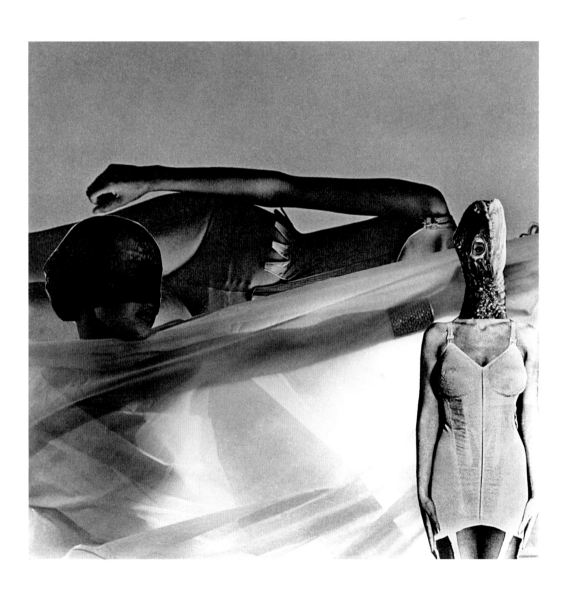

The scraping of wood
in the distance
was a dark mountain

The sun
big and sullen,
full with fruit,
wrapped round her its dense restless fur.

There were
a thousand mosquitoes
selling their bodies
to her eyes.

She arched her back
against the rhythmic veil
and on her pelvis,
coiling,
the sweat gleamed gold.

Of the hillside
swelling
remained a succulent cave.

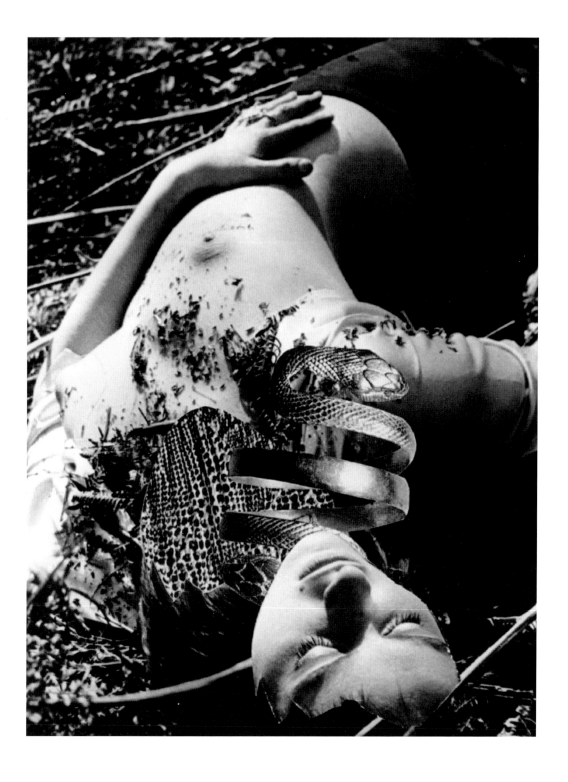

THE WINGED SUN-DISC /
THE RIDDLE

THE RIDDLE
\THE WINGED SUN-DISC\

Personification

of the vampire myth

Personification

of the vampire myth

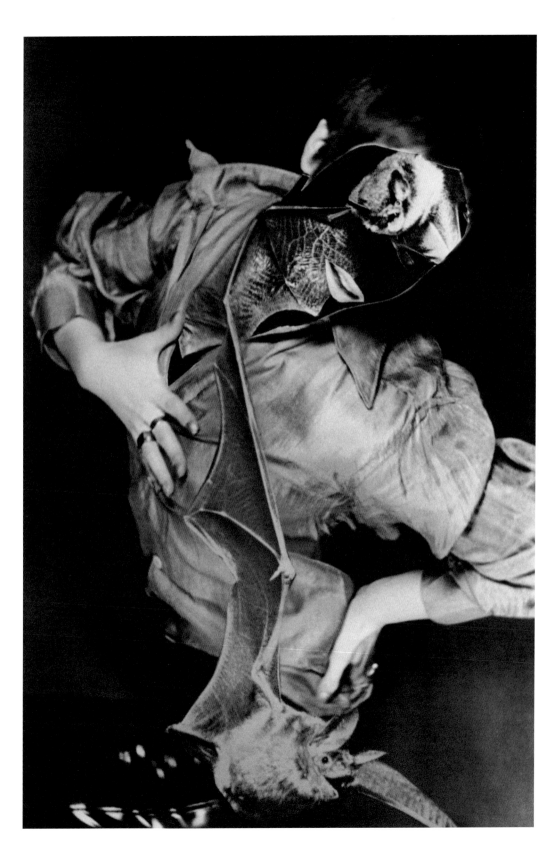

Flying in dreams
Symbolises erection.

Ejaculation.

The Angel
of Death.

Flying in dreams
Symbolises erection.

Ejaculation.

The Angel
of Death.

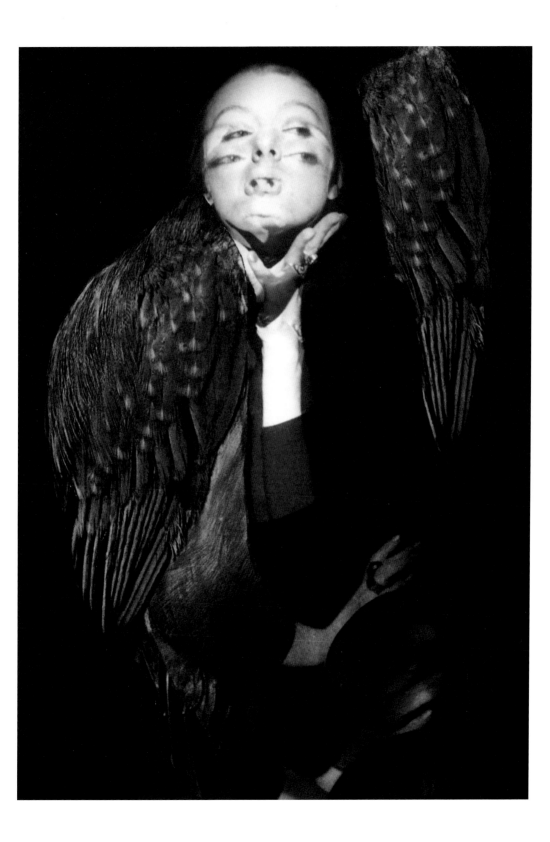

Leda legend
necrophiliac
the wind that whipped
your glossy loins
your hair
like feathers
throbbing still

But you are just a young girl
pinioned
by womanhood.

Leda legend
necrophiliac
the wind that whipped
your glossy loins
your hair
like feathers
throbbing still

But you are just a young girl
pinioned
by womanhood.

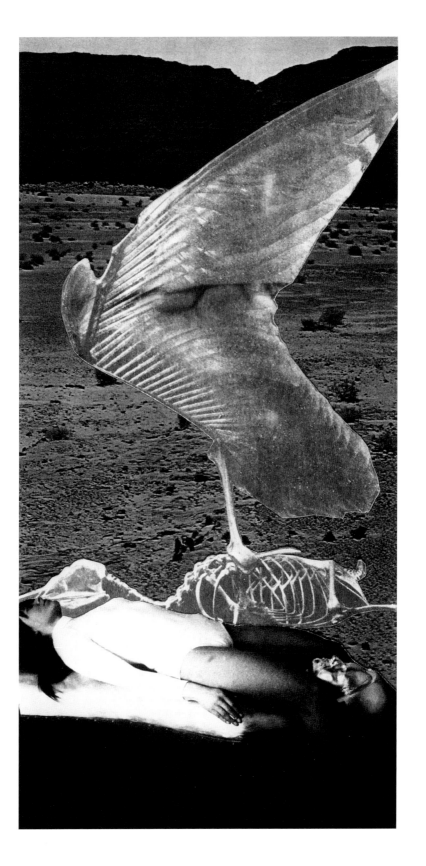

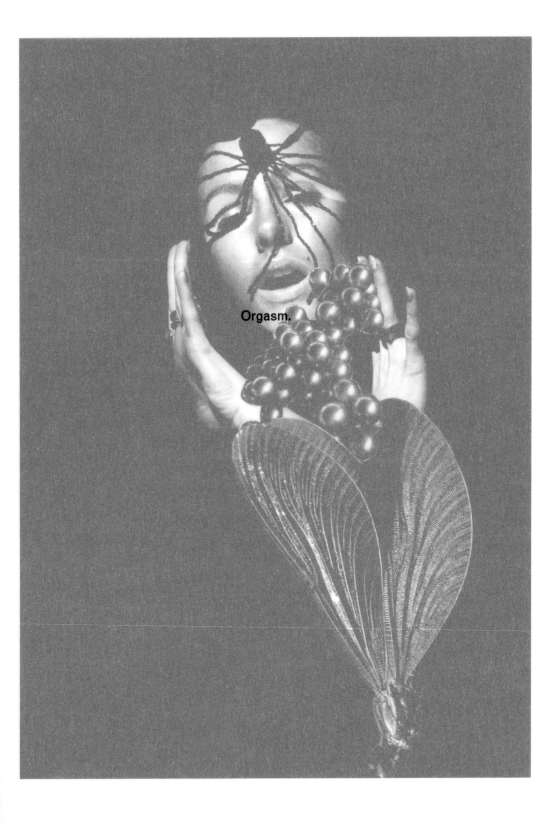

Did you really think
I would scream?

Killing me
you make me feel
wonderful.

Did you really think
I would scream?

Killing me
you make me feel
wonderful.

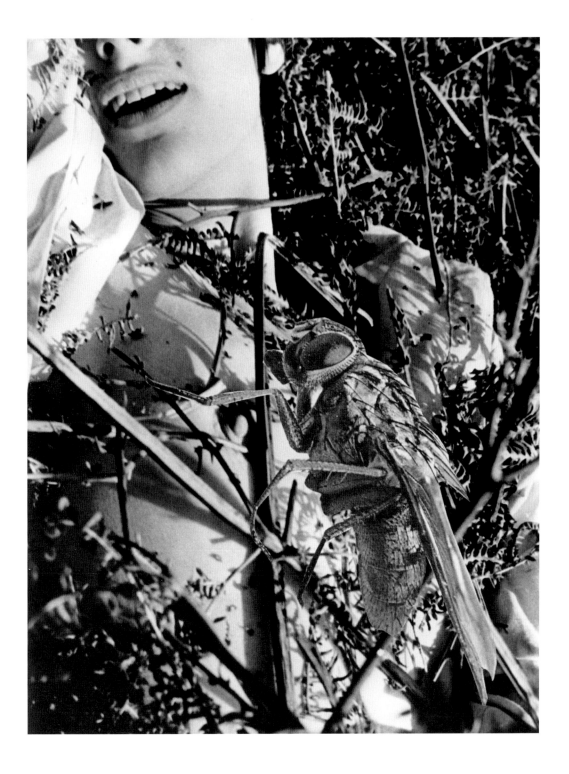

Passivity is the active fantasy

The victor and the vanquished?

The love that terrifies

is called fascination.

'The Story of O'.

Passivity is the active fantasy

The victor and the vanquished?
The love that terrifies
is called fascination.

'The Story of O'.

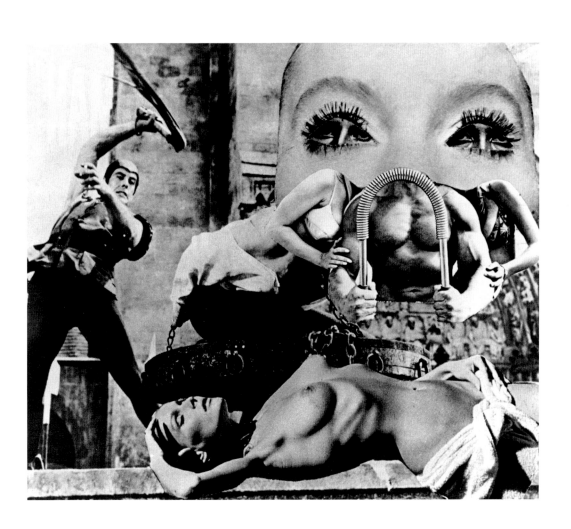

My palms are riveted

by the 'fixed idea'.

I am the riddle of Egypt

the Three in One.

As I pose each question

I sway my thighs

Immortality frightens me

BUT THEY SHALL NEVER

STEAL MY EYES.

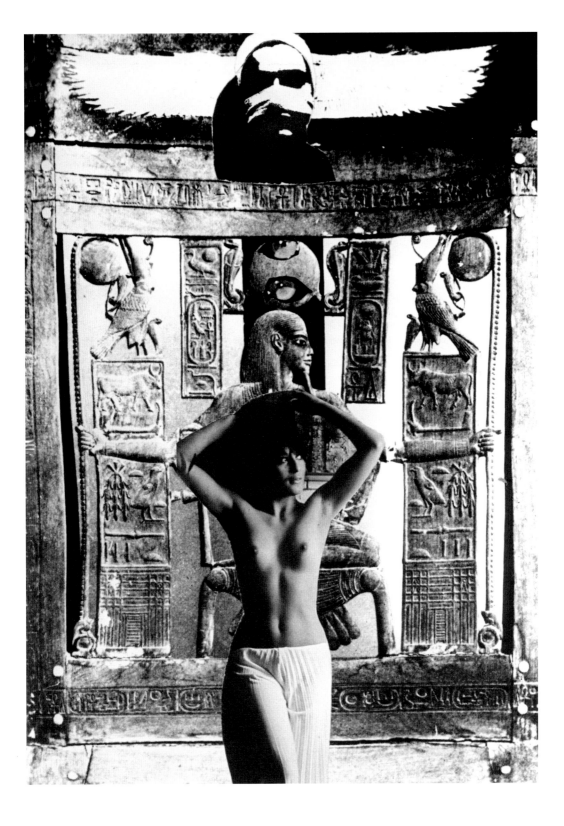

Clues to the stigmata myth: —

Passing into his body

She incorporated pain

Sanctified the flow
 of blood

and gave herself

more mouths

 more eyes.

Clues to the stigmata myth: —

Passing into his body

She incorporated pain

Sanctified the flow
of blood

and gave herself

more mouths

more eyes.

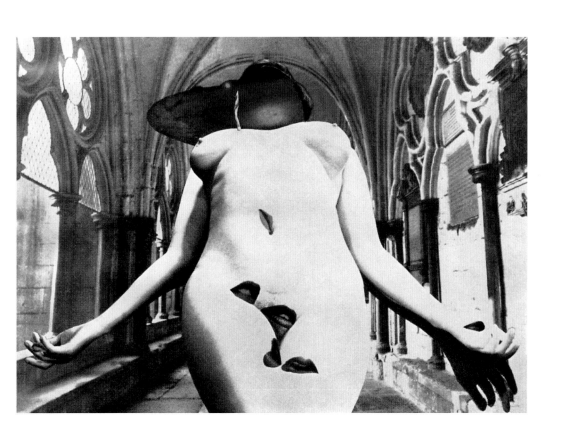

History of the Matriarchy.

History of the Matriarchy.

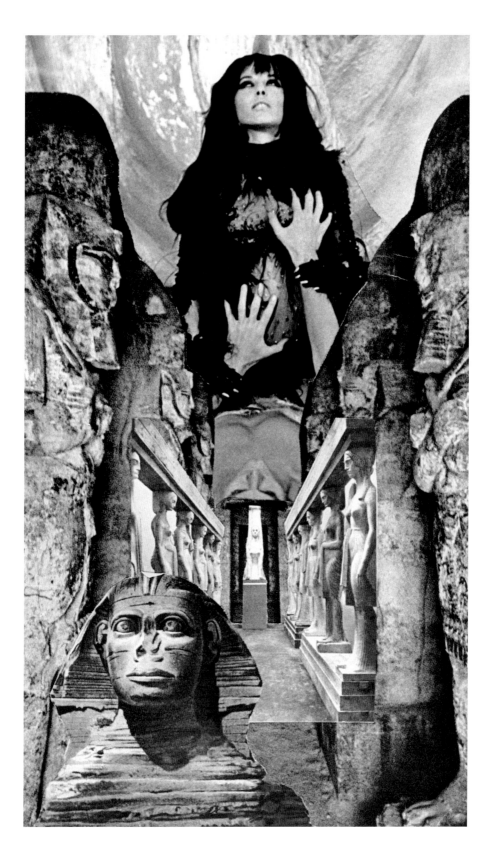

THE DISEMBOWELLING

'All brothers beneath the skin'.

Woman-meat is not easily digested

the breasts are fatty,

the stomach swollen,

the bones keep getting in the way.

(However, thoughtful dissection should prove the point).

'All brothers beneath the skin'.

Woman-meat is not easily digested
the breasts are fatty,
the stomach swollen,
the bones keep getting in the way.

(However, thoughtful dissection should prove the point).

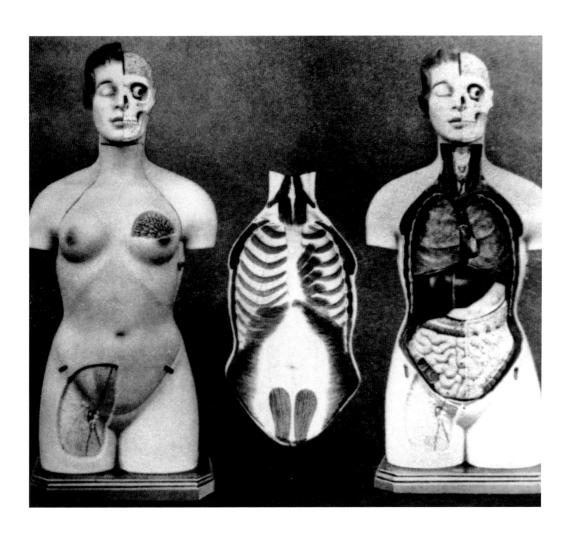

Contact with beauty.

Keeping in touch.

Inter-relating.

The quick
and
the dead.

Contact with beauty.

Keeping in touch.

Inter-relating.

The quick
and
the dead.

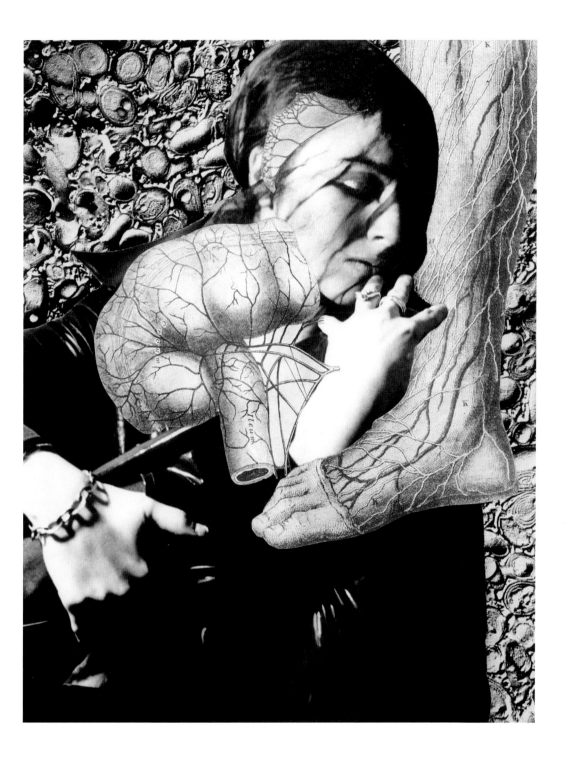

The first incision
is always most brutal.

There are so many layers

to pare away,

re-pair.

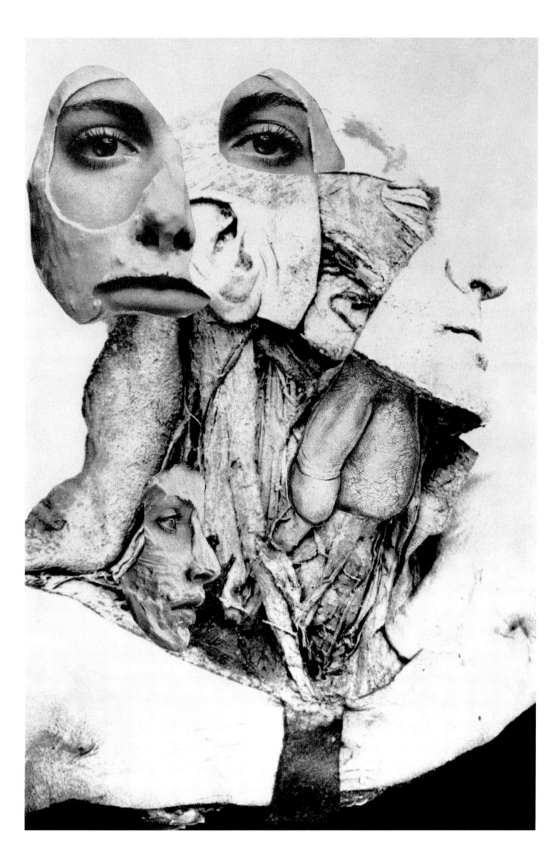

The filaments of structure the fragments of dreams

 p
 o
 u
 r
 i
 n
 g

 Into: — 1. The all-seeing eye.
 2. The 'New Fetish' as title
 to the collected works.
 3. My broken body as your incubator.
 4. Symbols of transformation.

Brassiers are boned to hold the sagging flesh

(but feel, my breasts are soft and full of milky veins
of translucent whiteness, bone china to the lips).

 'The meat is tougher near the bone'.

 The rigid member
 burst
 the mucous membrane
 of the eye.

The plaster in the mould
solidifies with time
its vitals gleam exposed
wherever the case is chipped away.
(A birth is callous to its womb).

 Tattoos should vary
 with the constitution.

Her sack-of-blood body
was ruptured; dry as bone.

The fragments of dreams The fragments of structure

b
o
u
n
d
i
n
g

into: — 1. The all-seeing eye.

 2. The 'New Fetish' as title
 to the collected works.

 3. My broken body as your incubator.

 4. Symbols of transformation.

Breasts are boned to hold the sagging flesh

(but feel,' my breasts are soft and full of milky veins

Of translucent whiteness', bone chins to the lips).

 The meat is tougher near the bone.'

 The rigid member
 burst
 the mucous membrane
 of the eye.

The plaster in the mould
solidifies with time
passed away steals its vitals
whenever the case is chipped away.
(A pitch is callous to its womb).

 Tatters should vary
 with the constitution.

Her sack-of-blood body
was ruptured! dry as bone.

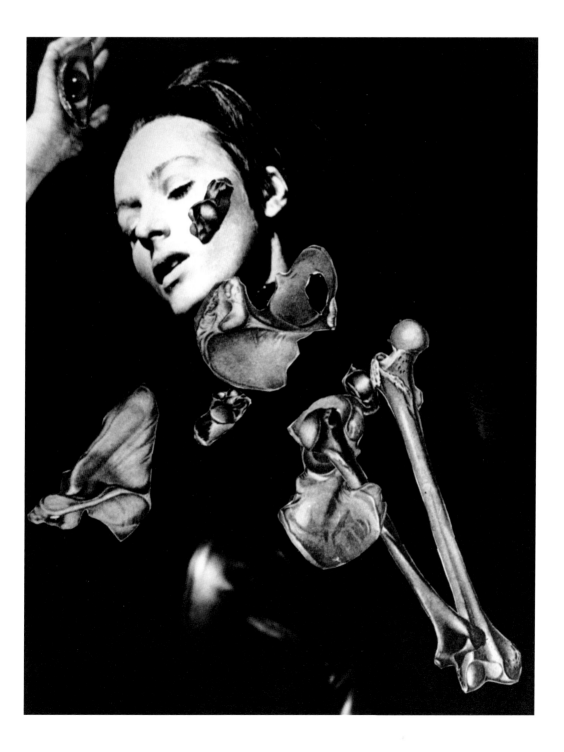

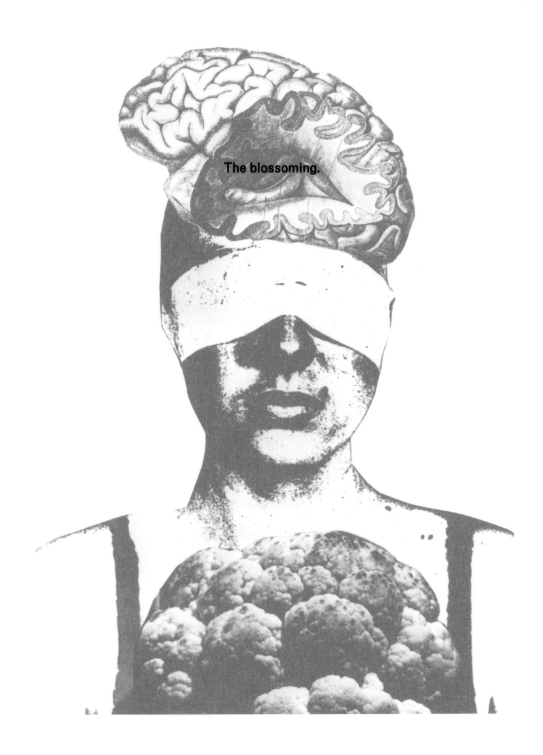

The surprised

tin opener.

The surprised
tin opener.

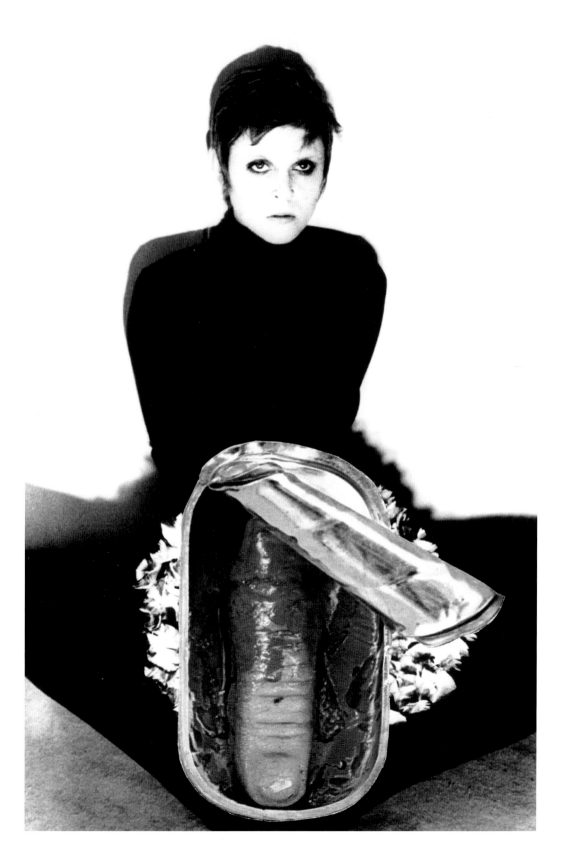

Open the sepulchre

INSIDE

a life-size replica
of the Virgin Mary
sings (repetitively)
in a ten octave range
variations on the theme

of love

then she ponderously
lifts her skirts

EXPOSING

all her children.

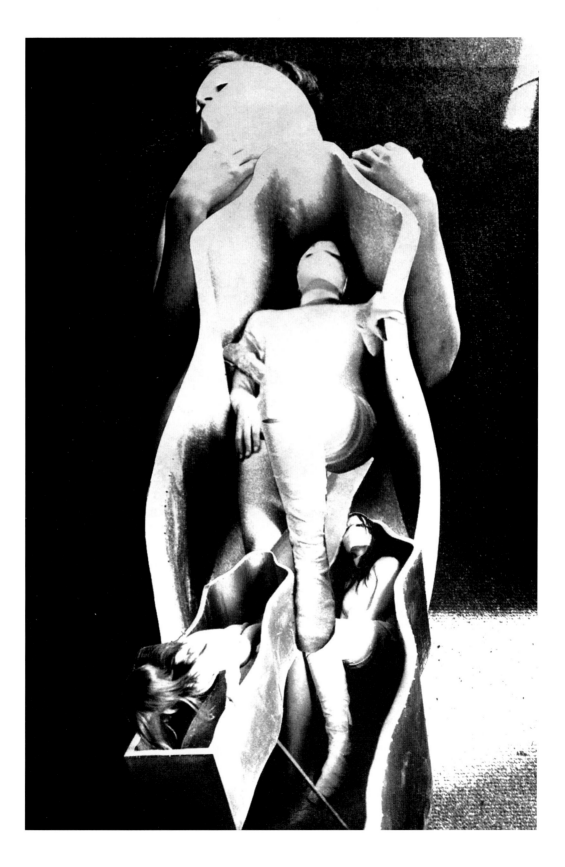

Renaissance

Renaissance

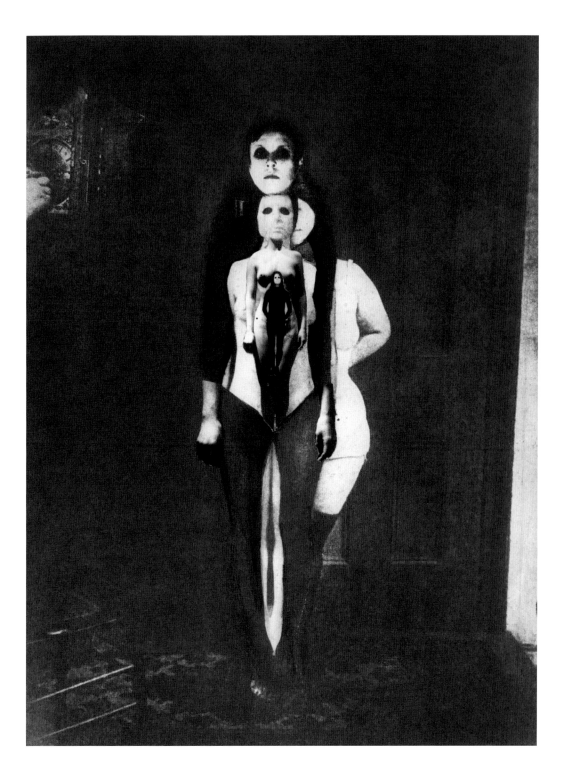

Cover girl

The film industry

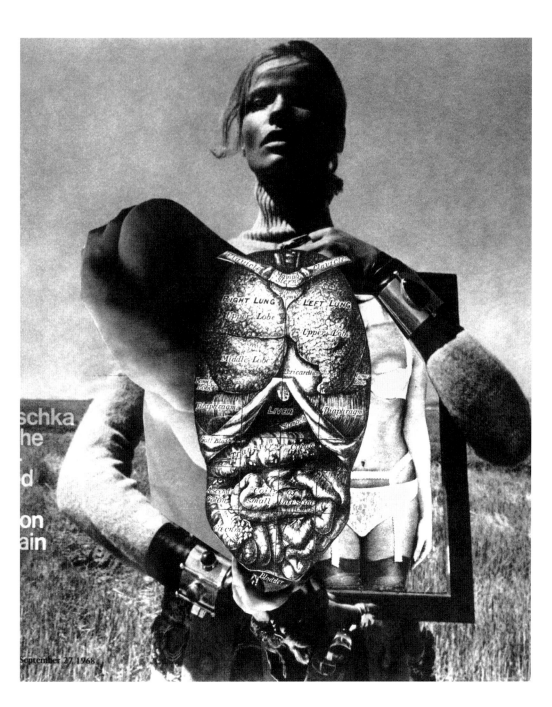

A MESSY BIRTH

A MESSY BIRTH

In the first hours of labour
the pain was so erotic
that my spine
turned to sap.

When I opened
my mouth
ecstatic
a waterfall
was rumbling

at its source.

At the pit
of a bottomless well
the larval worm

u
n
c
o
i
l
e
d.

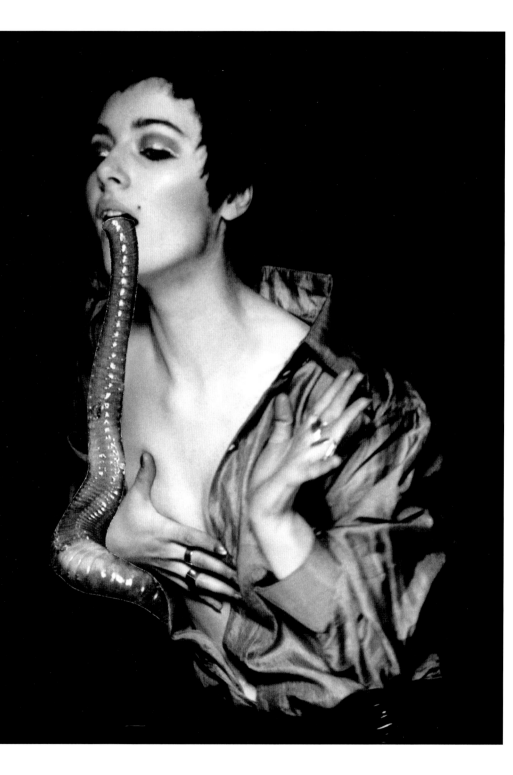

Birth of Kronus
(from the cranium's seventh rib) . . .
who will inherit

 the shower of gold?

 Aphrodite
 First transatlantic voyage
 of the hydrogen balloon.

Birth of Kronus
(from the cranium's seventh rib) . . .
who will inherit

the shower of gold?

Aphrodite
First transatlantic voyage
of the hydrogen balloon.

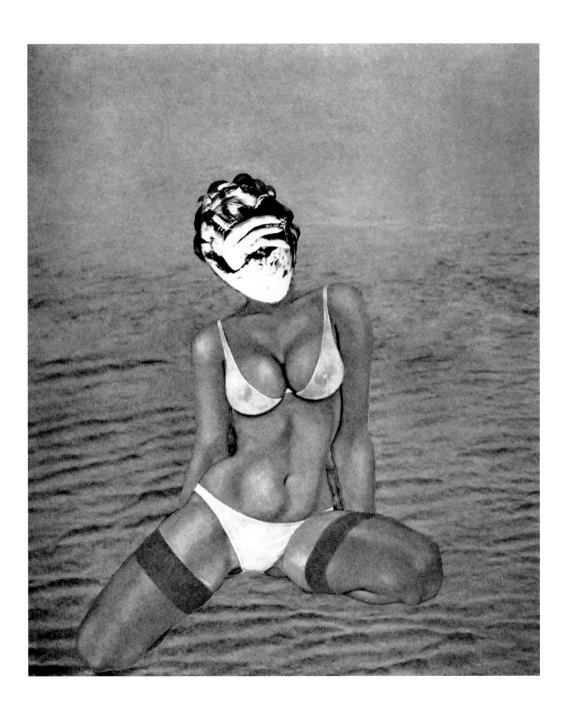

'Thus, as we have seen, through her erotic experience
woman feels – and often detests – the domination
of the male, but this is no reason to conclude that her
ovaries condemn her to live forever on her knees.'

Simone de Beauvoir

The safe period

'Thus, as we have seen, through her erotic experience woman feels – and often detests – the domination of the male, but this is no reason to conclude that her ovaries condemn her to live forever on her knees.'

Simone de Beauvoir

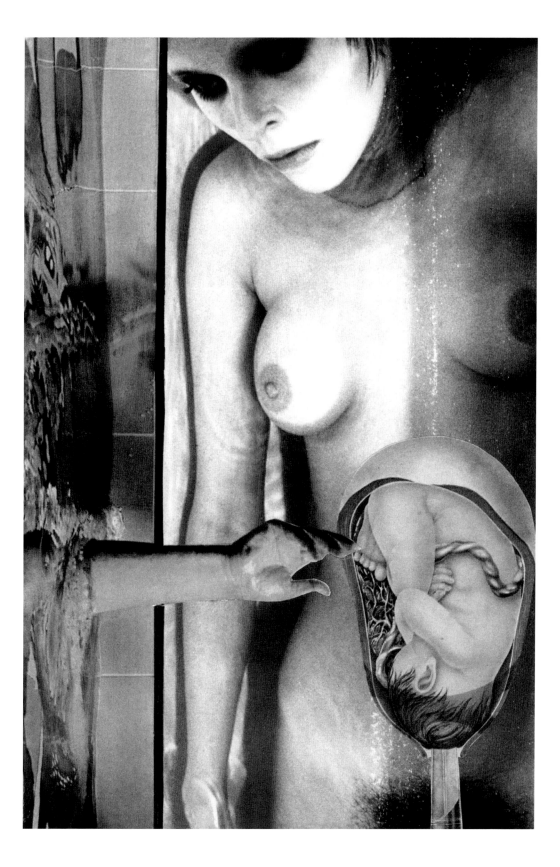

I was making the bed
and fell into it.

A white tunnel opened
stretching past birth

I didn't stop falling
until I hit the sea
and floated in flames

a flesh shell
cracked
into a well.

You were so full of me
that your tongue
burst open as a groin
and I entered the circle
of water
from every possible angle
sealing each exit
with a deafening tent
loosing such trails
of my wide-open mouths.

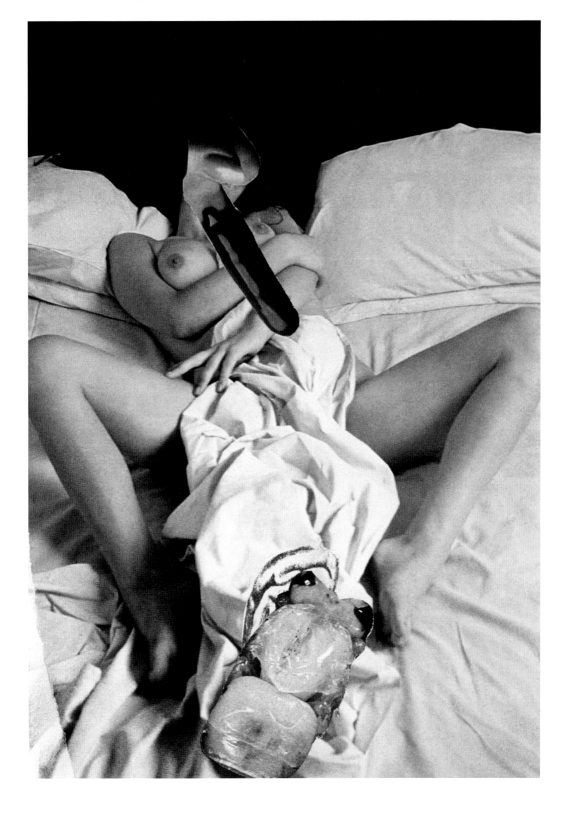

When she came of child-bearing age
the sheets turned into lead.

When she opened her great thighs
a precipice spewed forth.

Fixed in the subtle clockwork
of vaginas

the entrails
insidiously

enter out

When she lifted her face
the Gorgon's head

reflected our desire.

(Afterbirth takes the optimist
by surprise).

reflected our desire.



In the depths

of the nigredo

the ritual purification

mutually transforms.

In the labyrinth of sweat

the inferno's intensity

breeds mutations.

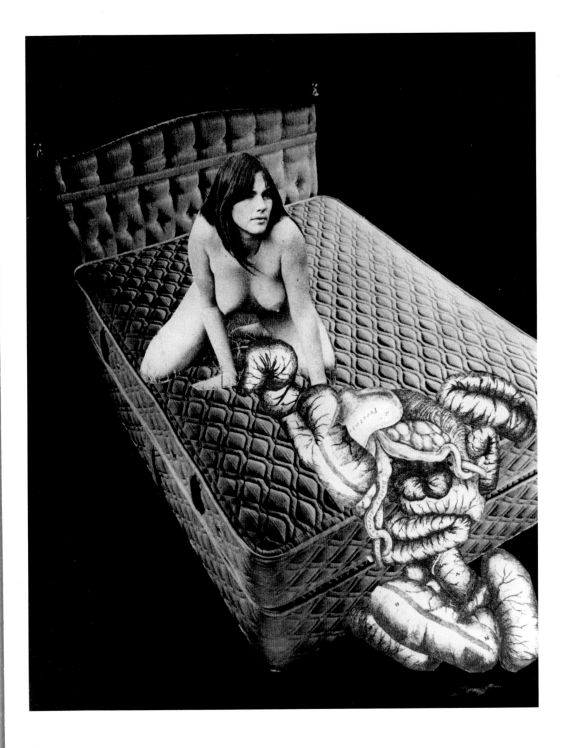

In the depths

of the nigredo

the ritual purification

mutually transforms.

In the labyrinth of sweat

the inferno's intensity

breeds mutations.

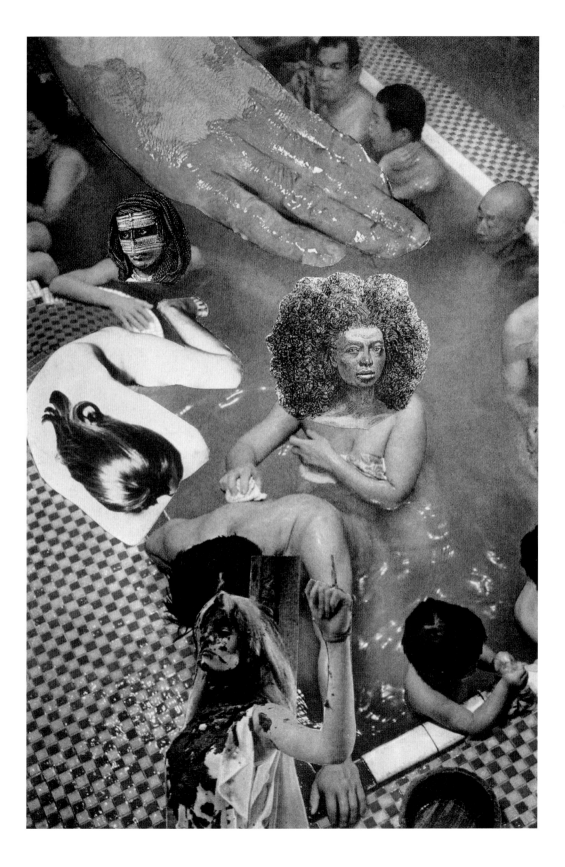

How dark it was

before the dawn

. . . the baby of pure gold.

How dark it was

before the dawn

. . . the baby of pure gold.

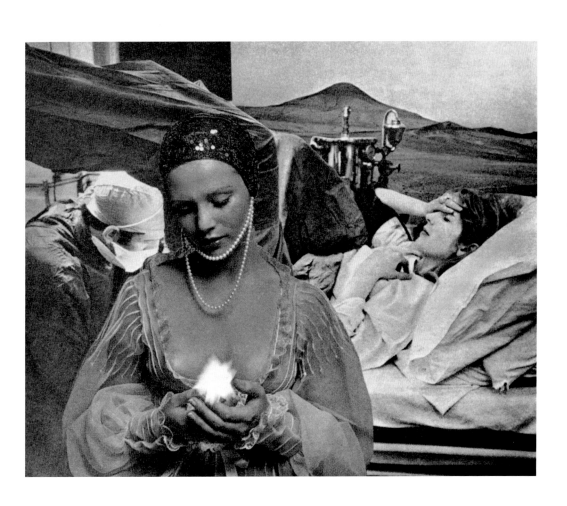

THE HERMAPHRODITE

THE HERMAPHRODITE

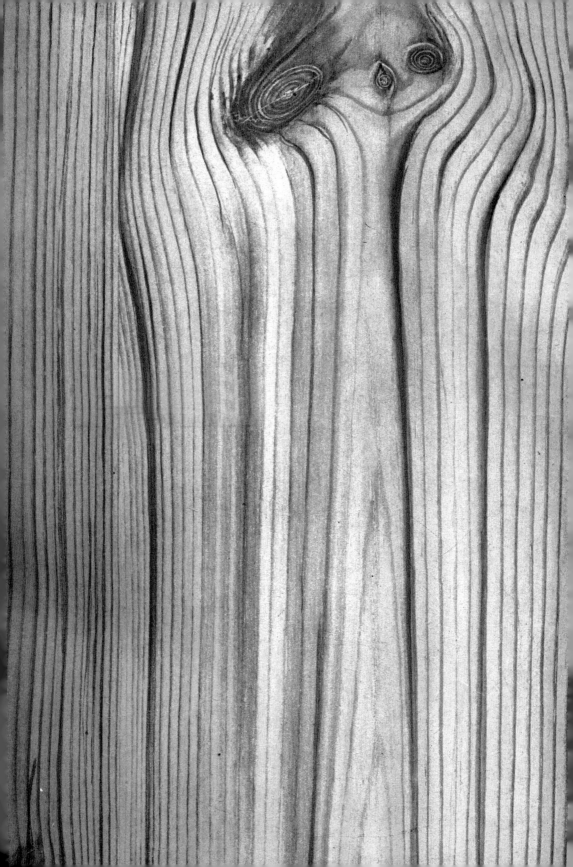

Transmutation
of the equatorial forest.

Here everything grows.

'The landscape changes three times.'
Max Ernst

Transmutation
of the equatorial forest.

Here everything grows.

'The landscape changes three times.'
Max Ernst

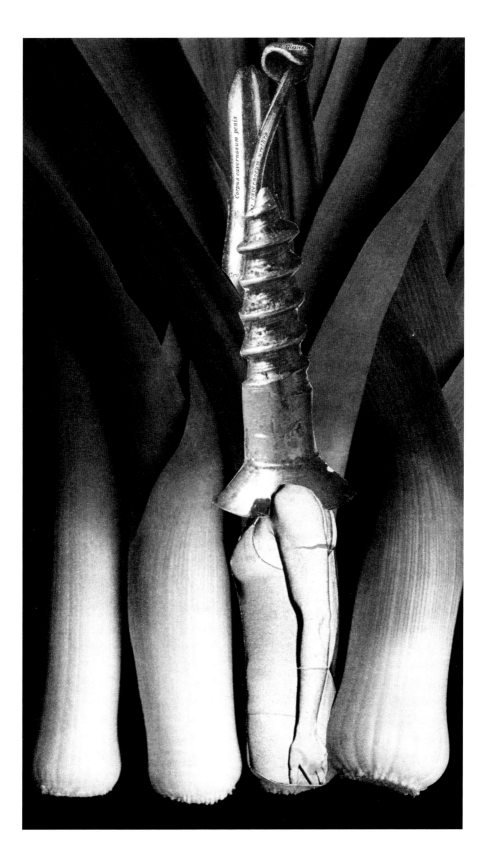

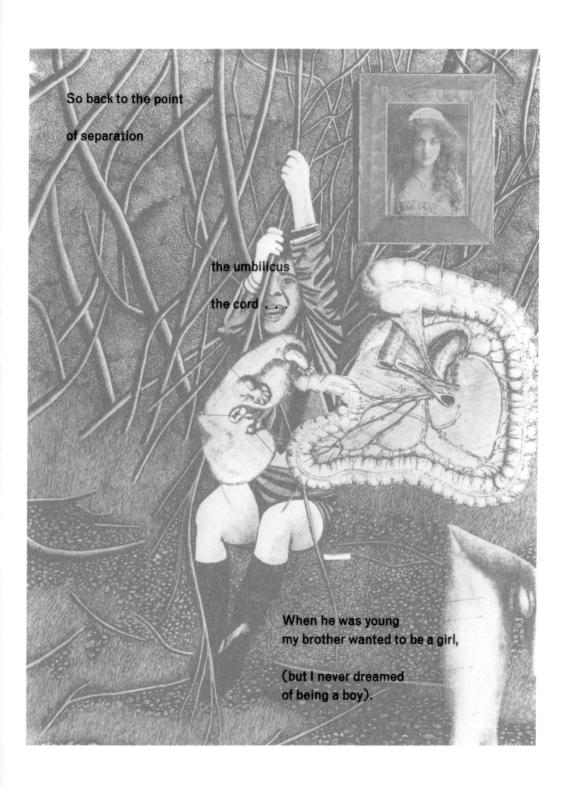

So back to the point

of separation

the umbilicus

the cord . . .

When he was young
my brother wanted to be a girl,

(but I never dreamed
of being a boy).

The trauma of expulsion

thrusting again

we return to the scene THRUST

of the crime

turning ourselves upon

the spit

to find a way back

 rifled

 to the womb.

('What happened to my manhood?' she cried).

THRUST

The trauma of expulsion
thrusting again
we return to the scene
of the crime
turning ourselves upon
the spit
to find a way back

rifled

to the womb.

('What happened to my manhood?' she cried).

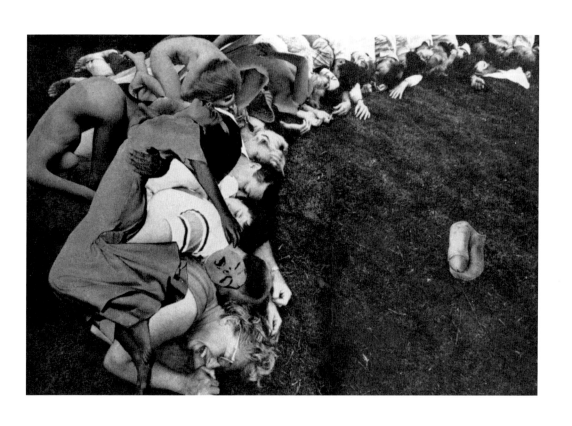

. . . Leaving the cord
 trail
through corridors of time
she could
 retrace
her steps

to find the centre
kill the monster

(Two beings
 housed
 within a single skin).

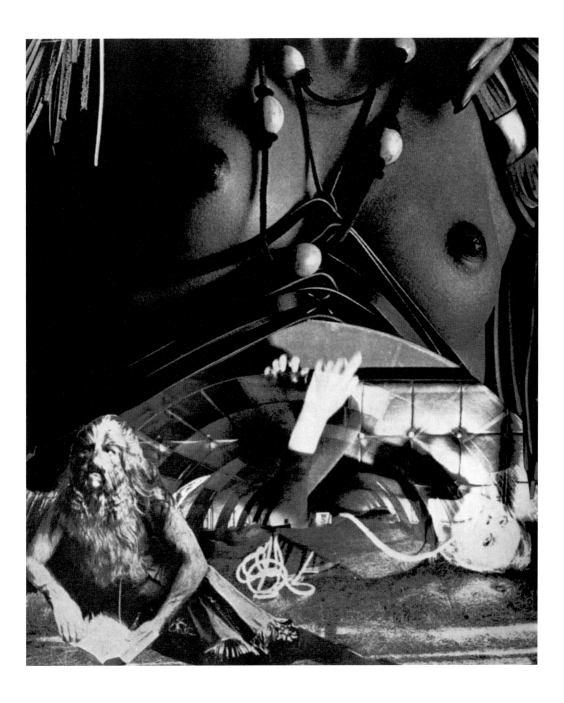

At the still point
where the hubbub dies away
we turn

restless

in our sleep
and leave each side

uncovered
to the sky.

(I wanted to catch you
as you fell

but you passed
straight through me).

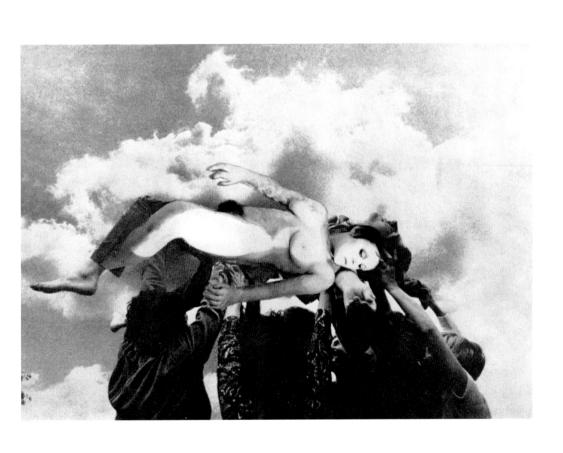

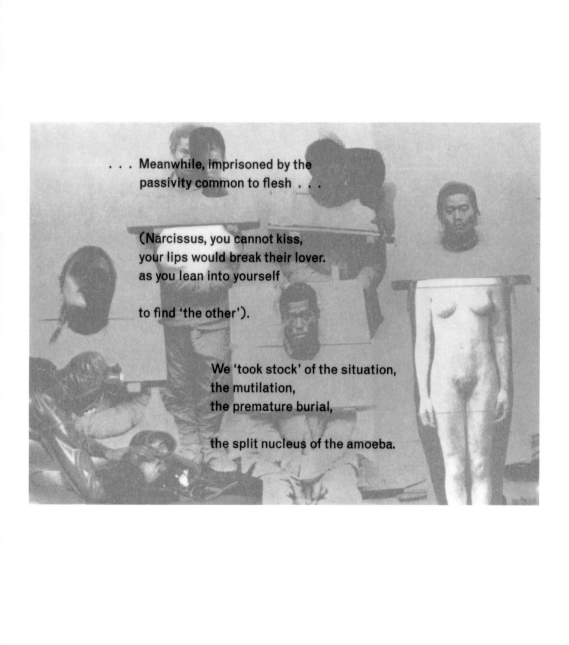

. . . Meanwhile, imprisoned by the
passivity common to flesh . . .

(Narcissus, you cannot kiss,
your lips would break their lover.
as you lean into yourself

to find 'the other').

We 'took stock' of the situation,
the mutilation,
the premature burial,

the split nucleus of the amoeba.

Compromise to form
a solution.

Disintegration
of the family.

Reintegration
of the personality.
Life out of death.

(But sexuality
holds surprises for us all).

Our roles are interchangeable
in the old beginning.

Reconciliation
the collage which

laminates.

With each new beginning

We open a book . . .

Compromise to form
a solution.

Disintegration
of the family.

Reintegration
of the personality.
Life out of death.

(But sexuality
holds surprises for us all).

Our roles are interchangeable
in the old beginning.

Reconciliation
the collage which

laminates.

With each new beginning

We open a book . . .

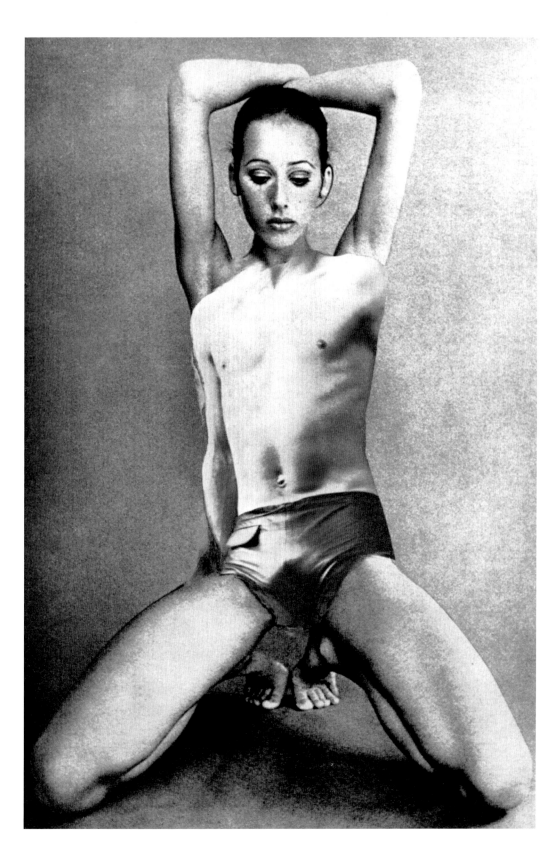

Linder Sterling opens the 1971 edition of 50% The Visible Woman *as if consulting a tarot deck.*

Linder (reading from the book):

"In the looking-glass, the same woman as Alice before the break-through.

'Mirror, mirror on the wall . . .'
The breasts which blossomed
beneath her touch
now fasten round her
as a grand facade.

– – The same woman – –

with her sisters
with her shadows
forming bodies
as a box."

When I was thinking about this conversation, I gave thought to Alice going back through the looking-glass. I'd love this conversation to capture the mirrored facets in the work that you were creating at that extraordinary time in British culture. I'd like to look at the taproot of *50% The Visible Woman* and the cultural seedbed that made it possible for what you were doing to take root. When would you date the earliest seed of thoughts that led to *50% The Visible Woman*?

Penny: I was always looking into things from a really early age. I always knew from when I was little that I wanted to be an artist. Art became a means of expression for me, right from when I was three or four on, when I could start using anything to make marks on a page, and had a natural facility. That, combined with the fact that I was just this natural rule-breaker—I couldn't help it. If there were rules, I wanted to smash them and do something different. One wonders why one has that tendency. I don't know, I think it's just an innate thing. You just don't fit into the norm. That unusual person has peculiar traits, and those peculiar traits don't fit into formulas. When you don't fit into formulas, then you have to smash the box—the box is a recurring theme for me—how can I smash the box that we're put into, the categories, the roles that we're meant to play? I always felt that I didn't want to inhabit those archetypes and that there were other archetypes that I wanted right from my youth. My father had wanted a boy, so, when I was young, I always wanted to be like one of the boys. I remember as a little girl, a boatman took us across somewhere, I think to the Isle of Wight, and he said, "Oh, come on in, sonny." I had my hair cropped short then and I was so proud. Right from when I was at art school, Farnham [School of Art] before I went to Chelsea [College of Art and Design], I wanted to be judged with the boys. I didn't really want to be considered on the level of the girls, because the girls at that point were very much second-class citizens in the world of art and as achievers.

I used to sign my name "Slinger" early on, so people wouldn't give me a gender identity. I actually sign "Slinger" still now, but after a while, I did very much own my feminine being. I wanted to transform the way the feminine was seen. I had to own it in order to try and transform it from the inside out. All these kinds of tendencies in me growing up and finding a lot of limitations in the social structure that didn't suit my nature. Getting into trouble from when I was young at school; I was always the odd one out, always being brought in front of the headmistress with something or the other, like kissing a boy in the playground when I was nine. Then the famous quote, which came at the end of one of my reports was, "There are thirty-six children in this class, thirty-five going one way and Miss Slinger going the other."

Before I came to art school, I was very interested in all the techniques of how you produce art. I liked to play with collage from an early age, but had a completely different sense of collage when I was young. I thought it was just bits of colored paper stuck together to make a new image. I didn't realize you could use whole images in relation to each other to make a new world. I was often at home, maybe I wasn't well, always tearing up magazines, making things, drawing things.

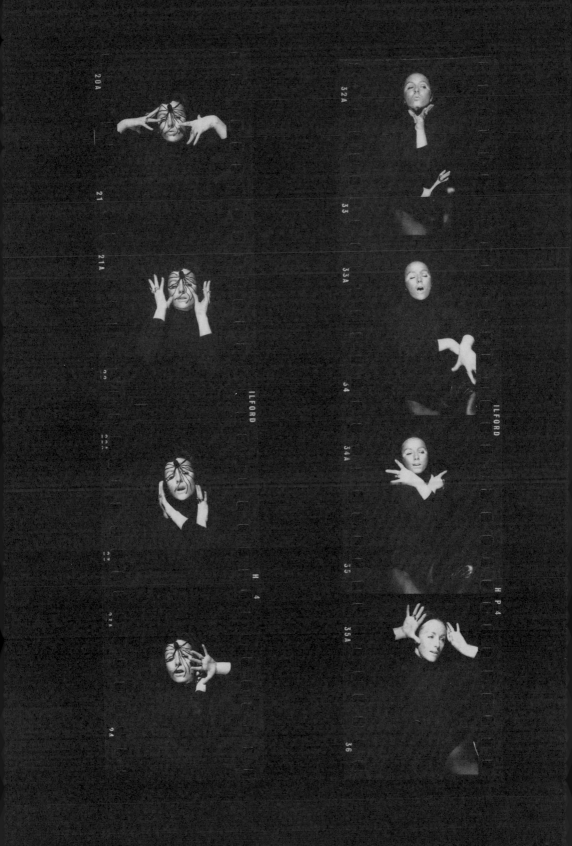

Linder: It's interesting—when I first started to create work in 1976, I dropped my surname to become simply "Linder" for the same reason: to avoid gendered identity. It was a very effective and liberating gesture.

You mentioned cutting up magazines when you were younger. I remember my mother's and my aunts' magazines from that time—I still cut them up now. Do you have strong recollections of the kinds of images of women being presented within *Good Housekeeping*, *Woman's Own*, *Vogue*, and other women's magazines at that time?

Penny: Yes, they were either rather boring-looking, frumpy, housewifey images, or they were quite glamorous images in fashion magazines. There was a combination of what was helping you be domestic and the idealized versions, which were presenting something that one would aspire to. Then, of course, strange corsetry and all that was both unattractive and fascinating at the same time.

The other magazine that I loved when I was younger was *National Geographic*. My parents used to subscribe to that. I've always been very entranced with nature in all its different forms. That was a big inspiration and, apart from the human, the animal and natural kingdom was something that I always found very inspiring.

Linder: Did you collect magazines? If so, were you an avid collector or a casual accumulator?

Penny: When I was young, the magazines were in my family. But as soon as I got older, I started collecting myself. I still have what I call my "blood bank" of collage material, things that I have collected and kept. I think a lot of artists have this tendency to collect. I tend to see the possibility in everything that I look at—I still have lots of ziplocks with different images. When I was creating, I'd spread everything out around me all over the floor, like a big sea of images that I could reach out and draw from and meld together.

Linder: I often find that I can cut out a motif from a magazine, thinking, "It's such an exciting motif," but I can't find any way of placing it within the works that I'm making at the moment. Sometimes it can be a decade later when I find the same cutout, and suddenly the cutout motif that you couldn't place finds its perfect position in the new work.

Penny: That's true. As artists who collect, it is about how you place those things that you've collected. One part is spotting those gems, and the other part is placing them in the crowns. You have to have both abilities.

I was looking at the difference between analog and digital collage, having worked in both forms during my life. Over recent years I have gone more digital. Working with digital collage, you have a vision and then you can really form whatever you want, because you have control over size, density, color—all these different aspects. Then you can use your consciousness to dictate how you want these things to relate to each other.

But with the analog, you don't really have that kind of control. You have an idea, but then you've just got the elements you've got, your grab bag, and you see how they play with each other. It's interesting, because you're not going to necessarily get what you think you wanted—it's not an exact science. It can be more illogical and spontaneous. It is a different process, and I appreciate both approaches very much.

Linder: I don't often work digitally, because my knowledge of the necessary software is inadequate and I haven't got the patience to learn. Plus I like the challenge of working with cutouts. It's like putting together a jigsaw puzzle but without a picture on the lid of the box. One tries to work out what should go where. I can spend days looking for the perfect photo of a rose to cut out!

Penny: Right! Just the right size and just the right color, just the right everything. In the days of *50%*, I'd look for imagery: I'd be in bookshops, I'd be in magazine stores. If I didn't have what I needed, I'd go on this treasure hunt to find the right thing. Then maybe I might find something, but it wouldn't be quite the right size, and then you would have to adapt. It's not only what you have, but also what you seek out once you know what you're trying to express. I've done a lot of that.

Linder: For you and I, whether it's digital or analog, it's the time one invests in making the work that sometimes seems excessive, especially during the initial search. Photo collage can sometimes look quite slick, especially now, because every image we see in every magazine has probably been through postproduction. Do you have a magpie's eye? Are you always seeking imagery?

Penny: If, in the midst of a project, I know there's something I need and I've been through my resources and don't have it, then I'd seek it out. But these days, things have changed so much with all this availability on the web. If there's anything I specifically need, I can find it somehow. Back then it was different; I had a different kind of process. The abundance of people working with collage is new—not only because of the availability of the digital techniques, which I think has been a huge factor in that—but because collage is probably now the most predominant popular art form. It's how all advertising is made. Film is like moving collage, shot against blue screen or green screen, with elements put in behind the characters. Collage is everywhere. But when I was coming of age in the art world, there were only some seeds of collage, which I found in the history of surrealism. I could look at, say, John Heartfield—he was about the only photo collage artist I had seen (I didn't even know Hannah Höch at the time)— but his work was circulating in a more political context. I got my inspiration from Max Ernst, but he was using old engravings instead of photography. At the time, using photo collage felt to me quite revolutionary, new, and fresh. Because the production of collage is so facile now—it's so easy to make a shocking or beautiful imagery. What is crucial is what your practice is, what your intention is, what your story is and its meaning. Because otherwise, it's all just eye candy.

I'm so glad so many people are empowered to be able to use these tools. For me, collage is one of the most liberating tools for the imagination, because it opens up all your creativity and your natural sense of composition. Why does something look right there but not right there? It brings out your aesthetic sensibilities. But then, the final image has to have breadth and depth, as well as surface. That goes right to *50% The Visible*

Woman: What is surface value and what is intrinsic value? That's what I felt compelled to try and express back in those days: the inner workings of a woman, not just what's outside.

Linder: When did you decide that you were going to apply to Chelsea College of Art?

Penny: I did a two-year pre-diploma course at Farnham (now called University for the Creative Arts, Farnham). It was a very craft-oriented school. I wanted to be in fine art because crafts smacked to me of the feminine side of arts—applied rather than "pure fine art." However, I was able to use the different facilities and different departments: textile arts, pottery, bookbinding, as well as sculpture, printmaking, photography, and painting. I started working in all these different media and right then weaving them all together. I would use a craft material, but in a fine art context. I did make very good use of my time there. I knew I wanted to come to London. I was looking at the main art schools and I applied to three different ones. Chelsea was my number one choice. I really felt attracted to Chelsea, it just had a cachet to it. And I got in. Only when I got to art school did I feel like I was enjoying my education and in the place that I was meant to be. From 1964 to '66 I was at Farnham, '66 to '69 at Chelsea.

Linder: Were any of your tutors at Chelsea practicing artists?

Penny: Yes, that was the fortunate thing. There were some very good full-time teachers, but we had the part-time teachers who came in one day a week and who were the artists who were happening at the time: Allen Jones, Patrick Caulfield . . . Having successful artists there, rather than just academic teachers, made it very exciting and dynamic. I wanted to hang out with them, go to the private views, and find out what this whole scene was about. So that's what I did. As I was lucky enough to be an attractive young woman, I was able to enter these circles. I wanted to learn and be on the scene. I felt I was meant to be this really breakthrough woman artist who was going to be—I used to laughingly say—"Lady Picasso"!

Linder: I went to art school in 1973, and my friends presumed that I was just lying around on a chaise longue each day enveloped by clouds of incense. But the reality was that at art school I worked far harder than any of my friends from grammar school. At art school, I worked really hard. Was it the same for you? You must have been so incredibly industrious to produce a book, a film, a thesis, and an installation in your final year?

Penny: I wanted to make use of every moment of this opportunity. I'd be one of the first ones there in the morning, then leave at nine when the art school closed at night. Also it was the '60s, but I didn't take any drugs when I was at art school. There were a number of students, for example, smoking weed and just hanging out, playing table tennis, doing one abstract painting a week. I thought, "Oh, no, I don't want to do this. I don't want to drop out, I want to drop right in." I wanted to really claim my place in the art world and use every moment to do as much as I could with the facilities at the school, which were fabulous.

I was breaking all the rules at the time. I wanted to work in all the different departments and blend all the media together. Of course, the photography department didn't necessarily want to blend with sculpture, and so on. Now, I believe things are much more fluid. They ended up giving me my own studio under the stairs away from the other people so that I could work in my own way. I was a troublemaker. At the same time, I really gave it everything I had. When I presented my final diploma exhibition, I think they wondered what on earth I was doing. But when they saw everything together, Martin Froy, the head of the painting department, wrote, "We had to admit that it was a celebration." I received a first-class honors degree.

Linder: So here you are, this young woman who'd been so industrious and so adventurous. Suddenly, there's this moment of extraordinary blossoming for all around you to see. It reminds me of the tradition of the coming-out balls of the British debutantes. In a way, you became the debutante of your own ball, didn't you?

Penny: Thanks, exactly. It hadn't been handed to me on a silver platter. I wanted to claim my place. In all the pieces I was trying to show the integration rather than separation of the different media and means of communicating in art.

Linder: Was it also a period of integrating all the different aspects of yourself? As girls and women, the roles we were offered were relatively narrow in their ambition. Sometimes when I'm working through photomontage—finding, sifting, selecting, cutting, arranging, and then finally gluing—I sometimes feel that the same process is being reflected psychologically.

Penny: Absolutely. I would say two things. Both "woman" and "artist" were two roles in society that I thought needed a bit of refiguring. There was that traditional view of the "starving artist" in the garret, living this terrible life, but producing great art. I thought, "No, the artist's whole life has to be a work of art." Everything has to be integrated. Not only the pieces dedicated to the canvas or the sculpture, but how you actually live your life and present yourself as your own work of art. That's through constant re-creation of who you are. Early on, that felt to me very important. It was completely aligned with the whole idea of recreating oneself—being able to take the subject role in how one is viewed as an artist and as a woman.

I put myself in men's magazines naked with my art because I wanted to go into these venues where women were so objectified, but present myself as a very firm subject. If they looked at the image and were titillated, and then came to read what I have to say, they'd be taken aback. I wanted to do that. I enjoyed the idea of shock value, because women felt so taken for granted. I wanted to shake things up so that nothing could be taken for granted anymore and what you see is not necessarily what you get. All these things were part of this bag of tricks which I wanted to open up as this Visible Woman and show the innards, not just the wrapping. For me, it was always very important to be visible, because I felt I had something I needed to communicate. You need to be visible to make your communication. I found early on that if you're considered conventionally attractive—an attractive woman—you become visible. As a young woman, I used my visibility both in my social life and in my art.

I wanted to use it to be able to be myself and prove myself—that kind of visibility. That was something that put me a little bit at odds with some of the more militant feminists who viewed being attractive as playing into the paradigm.

Not much in the history of art really seemed to be tackling the psyche of the feminine: the inner workings, the dreams, the fantasies. It was a big blank, especially in the history of art. We've got a lot of male fantasies, but we don't get much of what's inside us. That was a big part of the subjectification rather than the objectification of the feminine that I felt compelled to be involved with. A major theme of 50% The Visible Woman is to show what's on the inside—not just the outer surface, where you are only seeing a half of what's really going on. The arts are meant to communicate what's inside. I wanted to say, "Let's peel off these layers and look at what's happening there."

Linder: Do you find with each decade that that impulse to go deeper inside becomes more urgent?

Penny: It took different forms for me, paralleling the different stages in life. Interestingly, more recently, I realized that it was really important to bring in the relevance of the wise woman, the elder, the wisdom of the feminine as it matures and develops, which is so lacking in our culture. When we're not the hot, young, magnetic feminine, we don't have so much of a position. I found myself becoming invisible again—and I didn't want to be invisible. My more recent work is with my own body again, using myself as my own muse at this stage of my life.

Linder: That's a beautiful coming full circle there, isn't it, back to 50% The Visible Woman. Let's explore that now. How did the idea for 50% The Visible Woman first take root? It's such a luxury for me to hear you talk about these times in so much detail.

Penny: It was all part of my thesis project. When I was in the library, looking through the history of art, asking, "What inspires me and what is the theme that I want to use?," I realized then that I was most interested in the human form, especially the female form—not in a representational way, but in a symbolic way. I saw examples in spiritual art of the East

and ancient art, but I wanted to take my subject matter nearer to home, closer to the contemporary art world. That led me to surrealism, discovering what I hadn't been exposed to before—none of our art history classes had shown me the collage books of Max Ernst. When I found them, it was an "aha!" moment. It was a revelation. "Oh, you can use collage to create these symbolic, mythic fantasy worlds that express dreams, other states of being and consciousness, and you can make it look seamless! You can make a new world." I knew that's what I wanted to write about.

Having the approach that I had to things, I wasn't content with just doing a written thesis, I wanted to make an artistic contribution. I did the written part, and I also made a film. The film was from my Early Films series, where I combined images that I had photographed, film of the book, and other source material with live footage I took of animals, the sea, inner organs, and so on, then pastiched those together in a collage that was my tribute to Ernst. I thought the best way to honor someone is to show that their influence has inspired creativity. I've always felt that about my work, too—that if I can inspire others, then it's doing its job.

I also decided to make the 50% book. I didn't want to do a copy of anything else. I wanted to use the inspiration Ernst gave me to create something that was mine. All this thought that I had around the expression of the feminine psyche I realized I could express in collage form. I hadn't, as I said, had much exposure to any kind of photographic collage. Ernst used old engravings. I thought, "I won't do that, I'll use photos. This will be mine. It will be paying tribute while creating my own art that has come into being thanks to the influence of this amazing artist." So that's what I did. I just started making these images and pulling on the bank of photos I had of myself and other elements on hand and just letting it spontaneously and organically grow into being. In the darkroom, I printed up all the photos of the images myself. I typed the poetry onto these layers of tissue paper— to interleave with and overlay the images. Because I studied bookbinding at Farnham, I was able to use those talents to create my own dummy books—I made three books, all covered in real snakeskin.

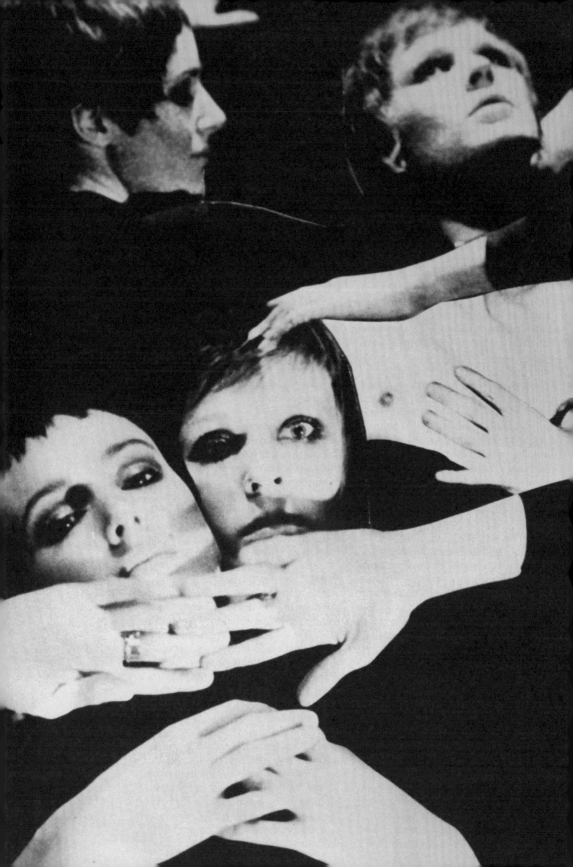

This was part of my diploma show and my thesis presentation. It straddled two realms. It was sitting in two places simultaneously, as part of my thesis and as part of the presentation of my artistic output. The book itself wove together some of my other practices. For instance, my mummy case—the big Egyptian sarcophagus that I made at Chelsea, over six feet long, metal, fiberglass top with life casts, filled with body parts and internal organs—that particular sculptural piece occurs in the book in a few images. As a work of collage, the book represented the very seeds of my practice. Bringing together different images, different media, and blending them together to create the statement I wanted to make, collecting from my own photographs and from photographs that I'd find in any other place. At the same time, blending those very freely, without distinction as to their source, then going into the darkroom to print them, then using my bookbinding techniques to bind it. The book itself was the result of the collage approach I had to everything I was doing, whether it was literally with cutup pieces of paper or the approach I brought to a sculpture, a construction. I believe surrealism as a practice allows one to take the parts of reality and reshape them into a surreality, a new reality that you are remaking from these parts that sat in one position before, and now you have in a different relationship.

Linder: You say, "Oh, then I just started doing it," but there's such an ambitious skill set in operation here. You were creating something very, very new. Yes, you were inspired in part by the collages of Max Ernst, but it wasn't as if there was a plethora of role models for you to choose from. Yours is such an extraordinary story. We've talked about spending long days at art college, but they must have been *very* long days for you to have achieved all of the above. It can take some artists five years to make even a book, but not only were you making a book, you were also making a film, photographing yourself, going into the darkroom, and more! The level of industry must have been so intense, plus developing a wide palette of skills to enable yourself to work across media at a time when the artists around you weren't doing that. You were collaging together your own practice, your own technique, on the spot, weren't you?

It sounds as though you were moving at an accelerated pace, at a very deep level. Your work was never about surface glamour or shallow spirituality. Did you always experience great certainty? Or were there times of uncertainty and doubt?

Penny: Every artist has self-doubt, but I've never really doubted my inspiration. My inspiration has always made me passionately involved and so engaged and so willing to go 110 miles for anything because I was so inspired. Feeling that, that's like a horse that's really got the bit between his teeth and he's just going because he's motivated. I was so motivated. Also I was so exhilarated to have all the facilities of an art school, a darkroom, a technician I could work with—all of this was just thrilling for me, what I always wanted. I was moving with the up-and-coming and established artists at the time, who were there on the cutting edge of culture. I felt like I was doing what I was meant to be doing. So, what could hold me back? Only my own laziness, and I didn't have that.

Linder: I can imagine now students, in Britain in particular, perhaps being quite envious, because you know now the fees for education are just really out of reach for a lot of people and facilities are shrinking within art schools. I'm sure younger artists must hear all of this and it must sound like this kind of paradise. Paradise Lost, literally, in most art schools in Britain now.

Penny: I had a grant, but the grant wasn't really enough. But I felt it was a privilege to have the opportunity I had, and that's why I wanted to make the most of it. Even if I didn't make the most of it in the most conformist way, I certainly made the most of it on my terms. We didn't have, for instance, a film camera in the art school, so I went over to the polytechnic across the road and I borrowed their 16 mm camera. I had—both then and even after I'd left art school—the technicians in the art school help me make my creations. The person who taught photography took pictures of me for me for my work. In fact, a lot of the pictures in *50%* were taken by my boyfriend at Farnham; he was the teacher in the printmaking and photography department.

So, I was able to spend overtime in printmaking, photography, learning that, and he also photographed me. I guess I set the tone then for the way that I treat these kinds of photos. It was pre-selfie, so I had someone else take the photo of me that I wanted to use for my work. Even if they were taking the photo, I thought it was my photo, because I was directing.

Linder: Art directing. Again, you see yourself as both the object-subject, which is kind of psychological—I can do that, too. It's like a separating out psychologically, isn't it, when you're both subject and object at the same time?

Penny: Right. I was against the objectification of women, obviously. At the same time, I didn't mind making myself an object if I was the subject. It's like being in two places at once. That's part of a whole multidimensional way of seeing the self and seeing the potential of the human being. I love that and being able to play with the fact that one can have many roles. This is another thing that's slightly at odds with some of the feminists of the time—"No, you can't be playing out these sexy roles. Oh look, you're looking submissive here . . ." To me, the beauty of it is to be able to inhabit a full spectrum of positions.

What are the more evolved qualities of the feminine that we can seek to invoke? All this is part of not having a one-dimensional view of who one is. In observing that women were viewed in certain kinds of ways, a lot of the things I explore in *50%* are about that view and role of women. I'm looking at childbirth, for example, because, is that what I want? I ended up not having children myself, and that was a conscious choice. I knew early on that I wanted my art to be my children, and that's what I did. But I was looking at it because it was an important piece of being a woman—you can't not look at that. Understanding what the pill did, for example. I was sixteen when I started taking the pill, so I was just coming out into the world and suddenly there was sexual freedom. You asked about the seeds of *50%*. I'd always had an interest in the erotic, in the sensual, and in these taboo areas. I remember secretly reading copies of *Lady Chatterley's Lover* on the train when I was about thirteen, and then I got into trouble for dirty limericks at school and all these risqué things.

Though I've never particularly wanted to make sociopolitical commentary, there are things that just seep into your psyche. The horrors of Vietnam are embedded in there too; for instance, the collage that has the bullets and the face mask.

Linder: *50% The Visible Woman* isn't only a book of photo collage—interspersed between the pages of imagery are semi-transparent pages printed with text; rather like the Roman god Janus, each page refers us backwards as well as forwards. Let's talk about your writing now.

Penny: Yes, in the book the sheets are like veils, a veil that conceals and reveals. I have always had, I feel, a gift with words, as well as with images. And the kind of words that I like, especially in relation to images, are not the kind that explain something away, but those that can paint the same paradoxical pictures, verbally, as images do visually. I love the frisson, the energy, the play, the next dimensions that are created when you can use both of them, without either of them defining or explaining the other, each one like another veil on the same mystery. That's why I love poetry and the poetic form. It's always as if words tumble into my brain, like music: they come in and then I have to write them down. It's very autonomous and intuitive. I feel it's a gift. That's the inspiration, the pure stuff pouring in. I don't like it when I have to craft it too much; editing becomes tedious to me, because I like that free flow.

I've written poetry from an early age. At Farnham, I presented a couple of books of poetry which I handcrafted. I wrote the poetry and did the bookbindings of them. I like the adjunct of words and images. The poetic form, when I think about it, it's rather like a collage, because you have the freedom of nonlinear thought. That, to me, is the interesting place. It's surreal in the sense that you can put words together, like you put together cutup images, and their relationship has that same kind of, yes, poetic connection, rather than the rational connection. That's why the combination of collage and poetry seemed so natural. I put the verses on the overlaying page, placing the words over the image in particular places, like concrete poetry, to firmly establish, connect, and link the two media. These are little nuggets of obscure information which together create

some kind of synergy, which doesn't necessarily answer questions, maybe creates more questions—but it's more than the sum of the parts, and all part of that same landscape of the psyche, uncensored and raw. In fact, when I met the novelist Lawrence Durrell and he saw *50% The Visible Woman*, he said, "Your subconscious is in a rare state of cheesy entropy. Don't ever get psychoanalyzed, keep it that way."

(Laughter)

Linder: So you hand-typed the text onto paper?

Penny: Yes, on that dummy book I did.

Linder: For the published version, did you set the type?

Penny: It had to be typeset by the publisher, but I specified the layout on the page. The published version is a little bit different from the handmade version. The handmade was '69, it was finished then, but I then met filmmaker Peter Whitehead and we got together. He formed Narcis Publishing to publish the book and we were given a grant to do it from his patron, Tom Newman. A few changes were made in the published version. In this current edition—the fifty-years-on version—I am trying to synthesize the two versions, in some cases reverting to the unpublished handmade version, because that was my most pure output. The published one was slightly crafted, in some cases—*thought of* instead of just *done*.

We put the titles of the chapters, for instance, on the pages with the poetry. Whereas in the dummy, they have their own pages, and they're actually on woodgrain-printed paper. There were only nine chapters, while in the published book, there are twelve. For this version, I reverted to the original. There are about thirteen images that were left out of the published version which I put back in. In a couple of cases, where I had remade images, I put the one that I remade, as I liked them better, so I haven't included both. Hopefully, it's a real synthesis between the 1969 and 1971 versions.

Linder: It's really exciting to hear that each version of the book is unique. Again, you're editing and recollaging the past to include earlier works in the new incarnation of the book.

What really struck me when trying to look at the book with a very innocent eye was how contemporary a lot of that imagery is. It hasn't really dated.

Penny: I like that. As an artist, I've tried to be relevant and timely, but also to strike things that have a more timeless note to them, because who wants to be part of a time capsule? You want something that's going to live in a more archetypal sense. That's always been my intention.

Linder: *50% The Visible Woman* is still very fresh. The typography, and the subject matter, and myriad details like your eyeliner [in the collaged photographs]—it's unique to you at that moment in time, but the book also has a timelessness to it. It's also deeply attractive as an object.

Penny: I hope that with this republication we can make it not exactly the same, but create something which has an equal value as an art object in itself. I'm always interested in everything being an art object, not just being a book, or being a film or whatever media the work is in. It's important to me that they somehow transcend that media and become these special objects. As artists, we can't help being fetishists. The texture—how things feel—as well as how they look, matters. All of this is deeply relevant and brought into anything we create. The texture of experience—we want to offer an experience. If someone has the book, it's that idea of relationship, how you relate to a work of art and what give and take happens in that relationship. And to present something that leaves doors open for people to bring something to it themselves, so that they're contributing to an interactive relationship. Hopefully you have enough goods that you're offering that can make them feel full after they've had this meal.

Linder: There is a lot of Sphinx-like riddling happening in the book—both within the text and in the imagery used in the collages. It forces the brain (and the psyche) to work in a nonlinear way. Your statements and questions *in 50% The Visible Woman* go in deep—they really hit a target. I often find that a day or two later after reading a line like "The breasts

which blossomed beneath her touch now fasten round her as a grand facade" are still active within me, working homeopathically.

Your book still thrills me as intensely as it did when it entered my life in 1978. What's the relationship between *50% The Visible Woman* and *The Secret Dakini Oracle* (1977/79), which followed? How long was the gap between the two?

Penny: I did the bulk of *50% The Visible Woman* in 1969, so it was a decade after that *The Secret Dakini Oracle* got published. My second collage book, *An Exorcism*, came after *50%* and was published in 1977. With *The Secret Dakini Oracle*, I was trying to embody a longtime passion for oracles and divination, always feeling that this was an incredible resource. Everyone should be able to have something which employs the riddling you're talking about, which goes beyond logic and yet completely connects in a big, spontaneous, collective unconscious kind of way. Surrealism gave me the permission to be able to be that obtuse, to be able to bring together disparate realities in a very free and organic way without having to think it out too much, just let it channel through, appear, and manifest.

The *Oracle* was made very organically, but it also was redolent with not only my surrealist understandings but also my newly found passion for Tantra. All of that was imbued into it, just not in a linear, straightforward kind of way; more just letting it come through and seeing what emerges. I have found that when it's true to that spontaneous inspiration, it does actually tap into some greater truths which are a little bigger than what our rational mind can either comprehend or form. So it leaves space for another factor, this invisible unknown factor, which is the bigger romance.

Linder: Oh, can you say more about this big romance, please?

Penny: I guess this is my way of trying to put a form around the concept of inspiration. To me, it is a divine dispensation. My mind-sky is constantly filled with visions and ideas that feel a lot bigger than just little me. As artists, it's our job to develop the tool set to translate that inspiration which we've been gifted. That is the connection with the realm of spiritual reality, as well as the material one. As artists, we sit at that interface, weaving these threads together from the worlds, trying to form a kind of tapestry, which can be read like braille by all who touch it.

Linder: We've been discussing that which is visible and that which is invisible. We've been talking about photo collage and text. I'm very interested in the substance that holds these things together—the glue. When we're working analog, with photographs and print media, if the glue messes up, then the paper can tear. Or, if the glue isn't applied correctly and it doesn't stick, everything becomes unstuck. I'm very interested in glues. I'm interested in how, psychologically, we keep ourselves glued together. And if we sometimes find ourselves unstuck, what glues us back together again? When you feel psychologically and emotionally that you're coming unstuck, what is the glue that puts Penny Slinger back together again?

Penny: A quote comes to mind. One of my art school teachers said, "Penny wants a glue that will stick anything to anything." I think that's very true. I have experimented with different kinds of glues. Even now, when I'm analog—that is, working in a cut-and-paste manner—glue can get all over you and there's that forced alchemy with these substances that you don't necessarily want! Digital art has its own issues, like the results of repetitive action on the body.

I would say the glue that sticks me together is a sense of having a purpose in this world that I'm trying to manifest and live up to. Coming back to the art has always been the glue of my life. Even when I spent many years outside the fine art world, I worked on my art every day, just in a different context.

Linder: Circling back to surrealism, you invited me to Farley Farm in 2012. The journey had a shamanic quality, as if we were traveling back in time. That day left a deep impression upon me. It felt for you a very emotional journey. Can you tell me more about your time at Farley Farm when you were younger and when that would have been?

Penny: Well, Farley Farm belonged to [artist, poet, and biographer] Roland

Penrose, who came into my life when I was working on preparing my thesis on Max Ernst. I was pondering, "Who in England knows anything about surrealism?" It was a bit hard to find at that point. I had a friend, the Right Honorable Robert Erskine, who said, "You need to meet my friend Roland Penrose, he's got a great collection. He knows about that." I said, "Oh, I'd love to." So he introduced me to Roland. I visited Roland a number of times in his beautiful house on Hornton Street in Kensington, where he had a collection of surrealist work. I would talk to him about Max Ernst. He knew him personally and he'd written about him; he would show me the "elephant painting" [*The Elephant Celebes*, 1921]. He had such love for all the pieces and such a personal connection to them all. It was just exactly what I wanted.

Then, in 1969, I went to Paris and Roland came over at the same time and took me to meet Max Ernst. That was just before I had to hand in my thesis. I wanted to present to Max Ernst how I'd approached it, because I'd taken a rather Jungian approach. Meeting him, he was so kind and generous. He let me read, and Roland to translate, passages from what I'd been writing, for me to explain how I'd been approaching his work, and for him to be able to give me feedback. For him to say, yes, he felt that was right—what other endorsement did I need? That put wind in my sails to present my thesis. He invited myself and my girlfriend, Christine Pearcey, who took photos, to come to a party that he was throwing in the next couple of days. So that was how welcomed, how embraced, by him I felt. That was such an important meeting for me.

Then I invited Roland to come to my diploma exhibition. When he came, he said, "Oh, my goodness, Penny darling, I didn't know you made such beautiful things too." He immediately got me into the *Young and Fantastic* exhibition at the ICA [Institute of Contemporary Arts, London]. He was president of the ICA at that time. He became my patron for a number of years, in the classic sense. I went to Farley Farm many times. Lee [Miller, Penrose's second wife and a photographer, photojournalist, and surrealist muse] would cook these amazing meals, and I met Valentine Penrose [his first wife], who was also an incredible poetess; we loved each other. It was a very special time. Visiting again in 2012 was, indeed, emotional for me. When I met my partner Nik Douglas and I left London in 1978, I separated from the deeply nurturing relationship I had with Roland. There's a sadness in me about that. You often don't recognize just how precious and wonderful something is until it's gone. All of that was coming back to me when we went to the farm and remembering those days. It was very special for me to be in that milieu again.

Linder: Did you consider yourself a surrealist then? And do you consider yourself a surrealist now?

Penny: I did consider myself a surrealist once I discovered Max Ernst, because I felt this was my inspiration, this was somewhere I fit in. Although I knew from then that I was a post-surrealist, because I wasn't there in the heyday of surrealism, the movement, where all the interactions that were happening between the participants were so prescient, so magical in my mind. Surrealism presented tools for not only how to make art, but how to think, how to explore and delve into your subconscious. This kind of exploration doesn't have a time capsule.

Linder: Is there anything I haven't asked you that you want to say about *50% The Visible Woman*?

Penny: Throughout the history of art, I saw the role of woman as muse—usually through a man's lens. I wanted to refashion the role of the muse through my own lens. I wanted to be my own muse. I felt I could be more ruthless with my own image than with anyone else's. I felt that I had the right to mess with my image. That first collage you described when you opened the book features my face. I'm pressed against the glass, I've got plastic over me. I'm looking really ugly and distorted. I felt at liberty to do this with my own image, because it's mine. This was all an important part of transforming the muse archetype. I wanted it to be a mirror to reflect who I really am, rather than just how other people see me or want to see me.

Linder: It's a very, very powerful gesture to reclaim the muse as one's own. Psychologically not splitting open, more a sense of melding, becoming both muse

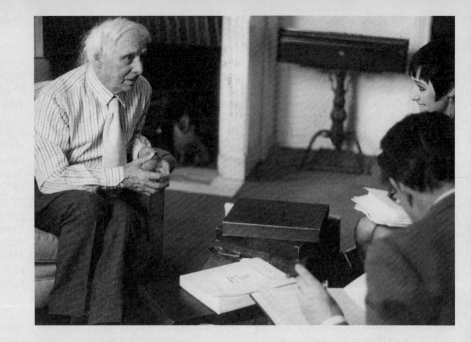

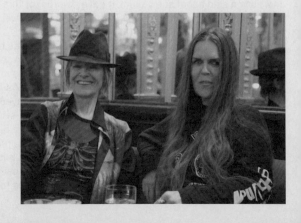

and the artist at the same time. That's quite a trick of the psyche to be able to hold those two positions, like a tightrope walker. The muse and artist. You've done that exquisitely.

We're still joining the dots, aren't we? We're still finding out about women artists that we had no idea about at the time. It was only in 1978, when a friend handed me a copy of *50% The Visible Woman*, that I knew anything about your work. I was immediately very curious to know who Penny Slinger was, but it was impossible to find out more in those pre-internet days.

When I first saw that copy of *50% The Visible Woman*—which a friend of a friend had actually stolen from a library—I was mesmerized. I'd never seen a book like that before. I used to spend hours looking at it, turning the pages over and over again, trying to work out its magic. I sensed that something really profound was happening, and I couldn't quite work out how that magic worked. My psyche was getting very, very excited. My intellect, too. The book was working on very different levels, more so than any other book I'd ever had in my hands. It had such a presence in my bedsit room.

Penny: You've said that it inspired you. To me, the most gratifying thing is to be able to feel that what one has contributed out of one's own heart, soul, and creativity has been something which has spurred creativity in others.

Linder: Definitely, Penny, it was like that for me. At that point in time, I was deliberating whether to exchange the "mark" of the scalpel for the mark of the larynx. I hadn't thought about this until now, but *50% The Visible Woman* gave me permission to use language abstractly and, as you said about surrealism, it gave me permission to be obtuse. *50% The Visible Woman* shaped songwriting for me, plus its accompanying visual imagery. Maybe I was trying to sing my version of *50% The Visible Woman* into being? I've never thought about this connection before.

Penny: A few years back, I made a collage for you, and I sent it to you. It was a thank-you for your help connecting some dots for me. You have been so instrumental in helping me get back into the fine art world—introducing my work to people who included me in the exhibition at Tate St Ives [*The Dark Monarch: Magic and Modernity in British Art*, 2009–10], and later to Blum & Poe. The collage was about you helping me find my voice again. I did a whole series called *Mouthpieces* when I did my second show at Angela Flowers Gallery in London in 1973. It was about the fact that we, as women, haven't had our voice. This is what is so incredibly important, even if we've come a long way since then. You helped me. So much damage is often done through being pushed into competition—not only in the art world, but in pitting women against women. This has been historically how it's all worked. Women have competed for powerful men. Now I think we need to shift that paradigm and support and connect with each other. We are the living proof of it.

Linder: To extend the metaphor of finding one's voice—one day we will duet together via the found image. I know that we've been saying this for over a decade now! When I was trying to find you so desperately in 2009, you found my email just in time to be included in *The Dark Monarch* show at Tate St Ives. Suddenly you returned to the British art scene, and that was such an exciting moment, especially sharing your work within the context of that exhibition.

Penny: That's the crux of it all, to be able to share so people can resonate with it.

Linder: I think that it's so important to leave a breadcrumb trail for the next generation of artists and for artists in a hundred years.

Penny: Yes, so we're crafting this together. "Collaboration" is one of the key words for this next stage of human evolution, I believe.

Linder: I was told a long time ago that the Aquarian Age is all about "we" and not "me." It already holds true.

50% The Visible Woman, true to its title, has stayed semi-invisible, hasn't it? When you left Britain in 1978, women artists were dispensable. We weren't cherished, and our paths weren't tracked in any way. It is time for *50% The Visible Woman* to become *very* visible. I have great hopes for the new incarnation of this book!

Images

1. Contact Sheet from *50% The Visible Woman*, 1968. Photographs by Ray Whewell.

2. Collage of photographs of Penny Slinger and Suzanka Fraey, 1969.

3. Max Ernst, Penny Slinger, and Roland Penrose in Paris, 1969. Photograph by Christine Pearcey.

4. Penny Slinger and Linder Sterling, London, 2017. Photograph by Dhiren Dasu.

Penelope Slinger
50% The Visible Woman

Editor: Penelope Slinger
Editing: Nicoletta Beyer
Production: Document Services
Copyeditor: Jaclyn Arndt

Printed by die Keure
Edition of 1,000

Published by:
Blum & Poe
2727 S La Cienega Blvd.
Los Angeles, CA 90034

ISBN: 978-0-9987360-3-7

50% The Visible Woman was first published by Narcis Publishing Ltd., London, in 1971.

Penny Slinger would like to thank: Ray Whewell for taking many of the photos of me used in the book; Suzanka Fraey for being my muse; Peter Whitehead for publishing the first edition of this book; Tom Newman for supporting the publication; Sir Roland Penrose for including the collages in the *Young and Fantastic* exhibition, Institute of Contemporary Art, London, 1969; Blum & Poe for supporting and enabling this new edition; Linder for our conversations about the book; Alissa Clarke and Steve Chibnall of De Montfort University, Leicester, for supplying material from the Peter Whitehead Archive; Christine Pearcey for the photo with Max Ernst; Dhiren Dasu for the photograph of myself and Linder; and the production team, especially Nicoletta Beyer and Rachel Topham.